DOMINIQUE LÉVY

NEW YORK | LONDON

Symmetries

THREE YEARS OF ART AND POETRY AT DOMINIQUE LÉVY

Edited by Sylvia Gorelick

CONTENTS

8 Acknowledgments
DOMINIQUE LÉVY
SYLVIA GORELICK

11 poetry is on the walls:
a preface
vincent katz

Poem

13 *Star, Being*
MEI-MEI BERSSENBRUGGE

Exhibitions

17 *Audible Presence: Lucio Fontana,
Yves Klein, Cy Twombly*

22 *Germaine Richier*

26 *Boris Mikhailov: Four Decades*

30 *Pierre Soulages*

34 *"Hypothesis for an Exhibition"*

36 *Gino de Dominicis*

38 *Local History: Castellani, Judd, Stella*

42 *Sotto Voce*

44 *Body and Matter: The Art of
Kazuo Shiraga and Satoru Hoshino*

48 *Roman Opalka: Painting* ∞

Poems

53 *Homage*
JACQUES ROUBAUD

55 *Homage to Calder*
KARL SHAPIRO

56 from *Kind Ghosts*
CECILIA PAVÓN

64 *Materia 0*
JOEY DE JESUS

66 *Materia IX*
JOEY DE JESUS

67 *autosacrifice*
JOEY DE JESUS

69 *Artist Statement #2*
TRUCK DARLING

70 *Artist Statement #3*
TRUCK DARLING

71 *Stretching Canvas*
TRUCK DARLING

73 *GEGO*
ANNE TARDOS

Exhibitions

77 *Gego: Autobiography of a Line*

82 *Alexander Calder: Multum in Parvo*

86 *Senga Nengudi*

88 *Gerhard Richter: Colour Charts*

92 *Robert Motherwell:
Elegy to the Spanish Republic*

Poems

97 *All Elegies are Black and White*
BARBARA GUEST

101 *A Bird for Every Bird*
HAROLD ROSENBERG

102 *Lament for Ignacio Sánchez Mejías*
FEDERICO GARCÍA LORCA

110 *To The Songbird Fallen
on the Forest Floor*
BRENDA COULTAS

114 *Love Poems from 2001*
LEOPOLDINE CORE

118 *It's Hard*
LEOPOLDINE CORE

Exhibitions

121 *Drawing Then: Innovation and Influence in American Drawings of the Sixties*

128 *Enrico Castellani*

130 *Enrico Castellani: Interior Space*

Poems

133 *Untitled*
MARY REILLY

134 *Garden at Night*
MARY REILLY

137 *[Twins and immaculate inseminated]*
BRUNO CORÀ

138 *Trous (Holes)*
EMILIO VILLA

140 from *Spells for Solids*
KAREN WEISER

147 *Bill & Ted's Excellent Adventure*
EDMUND BERRIGAN

148 *[Died in a back bone]*
EDMUND BERRIGAN

149 *Quipment*
EDMUND BERRIGAN

150 *Struggle*
EDMUND BERRIGAN

151 *[I'm not a guy who]*
EDMUND BERRIGAN

152 *Path*
YUKO OTOMO

Exhibitions

153 *Chung Sang-Hwa*

158 *Hans-Christian Lotz*

160 *Gego: Autobiography of a Line*

162 *Karin Schneider: Situational Diagram*

Poems

165 *A Performance Architecture*
ERICA HUNT

170 *Broken English*
ERICA HUNT

174 *Ode to the Artist in His Natural Habitat*
AMY KING

180 from *If I am Teachable*
SARAH JANE STONER

221 Poet Biographies

226 Exhibitions and Events at Dominique Lévy

Exhibitions

189 *Günther Uecker: Verletzte Felder (Wounded Fields)*

194 *Pat Steir*

198 *Joel Shapiro*

Poems

201 *On Balance*
ANGE MLIKNO

206 *These Pieces*
PETER COLE

212 from *Cry Stall Gaze*
ANNE WALDMAN

Acknowledgments

Artists and poets are the raw nerve ends of humanity. By themselves they can do little to save humanity. Without them there would be little worth saving.
 —Anonymous

As we go to press
It is silence that comes to me...

I stand in awe of poetry, grateful for the joy of this book and to all of you who have embraced this project and participated with enthusiasm.

There are poems that have changed my life because they have transformed the way I experience the world; there are poems that upon repeated readings have prompted me to life-changing decisions. I cherish repetition. And there are poems I choose to read over and over again as I know in my soul that they contain all the answers to what I have yet to learn and discover.

Poetry opens doors we may never dare to dream of, thrusting us into a larger world, lighting our eyes to the unknown, to the infinite possibilities of being alive. We are never the same after reading a poem that speaks to our own life.

I hope to share this passion with *YOUS*. In these last three years you have each made a difference in the life of this gallery and each of you is a precious participant in this adventure.

2017 is in the offing, new beginnings...

Dominique Leroy

Thank you to all of the poets who have composed new work for our exhibitions: to Anne Tardos for her poem *GEGO*, written for the exhibition *Gego: Autobiography of a Line*; to Mei-mei Berssenbrugge for her work *Star, Being*, published in the catalogue *Drawing Then: Innovation and Influence in American Drawings of the Sixties*; to Yuko Otomo for her poem *Path*, written on the occasion of the exhibition *Chung Sang-Hwa*; to Erica Hunt for her work *A Performance Architecture* and to Sara Jane Stoner for her piece *If I am Teachable*, both composed for performances in the context of Karin Schneider's exhibition *Situational Diagram*; to Ange Mlinko for her poem *On Balance*, and to Peter Cole for *These Pieces*, both written for *Joel Shapiro*.

Our thanks go next to the poets who have participated in the gallery's reading series, and whose original poetic work is included in this anthology: Leopoldine Core, Karen Weiser, Mary Reilly, Edmund Berrigan, Amy King, Brenda Coultas, Joey De Jesus, and Truck Darling—thank you for contributing such innovative writing to this book. Thank you to Anne Waldman for granting us permission to excerpt her collaboration with Pat Steir *Cry Stall Gaze*; to Cecilia Pavón for her text *Kind Ghosts*, and to Jacob Steinberg for his translation. Thanks to Jacques Roubaud for his homage to Roman Opalka, to Bruno Corà and Emilio Villa for their responses to the oeuvre of Enrico Castellani.

Our gratitude goes to Vincent Katz for his friendship and support of our program, and to Jessica Morgan for her collaborative spirit and dedication to the shared project of bridging the contemporary worlds of art and poetry.

Profound thanks to Dominique Lévy for inspiring this singular and powerful poetry program. A great thank you to the entire team at Dominique Lévy, and especially Emilio Steinberger, Begum Yasar, and Clara Touboul, without whom these three years of exhibitions would not have been possible. Special thanks to Mackie Healy, Valerie Werder, and Andrew Kachel for their invaluable work on our cultural programming.

Thank you to Sarah Wolberg for her thorough copy editing of this book. To Mark Nelson and Meg Becker at McCall Associates, and to Massimo Tonolli at Trifolio—thank you for your resolute commitment to our publications.

—Sylvia Gorelick

poetry is on the walls: a preface

vincent katz

poetry is on the walls. a potent call, from village or town, to be left alone, not to be bombed into oblivion, literally or economically. poetry has served an active function, through millennia, to keep the people alive, through touch of sound, communication. it is always sound, even silent, and began in song.

it is hard to comprehend how poetry from almost three thousand years ago has survived. it survived as an oral tradition, the word sung, until it entered, inflecting a culture. even more surprising is that the written word survived. the ancient greek historian herodotos must, somehow, have written down his conclusions on persians, lydians, egyptians, medes, and greeks; then copies were made and copies of copies, on through time. so much writing, of history and poetry.

poetry moves with dispatch; it was always entertainment, and news; it was history and morality; it was philosophy. and therefore survived. people made sure of that, at any cost. it was there, for whoever needed it. and that is still the case today.

poetry will survive, even if it has to go out in the cold, on the street, or beyond the street, into the woods, or desert. people do love it, they welcome it, and that is what we are celebrating here, the connection, among the arts, in this book that is a marker of devotion and pleasure that goes back millennia and will continue as long as the human species does. the poetry continued herein is evidence of the support these walls provide for further poetry, the poetry of today.

Star, Being

MEI-MEI BERSSENBRUGGE

1

In late afternoon, stars are not visible.

Everything arrives energetically, at first.

I wait to see what I'll recognize, as diffuse sky resolves into points of light and glitter.

When Venus appears, objects are just visible; silhouettes seem larger, nearer; voices are audible at a distance, though words don't make precise sense.

Glancing to the right of Antares in medium blue, I intuit cosmic allurement.

Stars arrive non-visually, first.

I practice to see light in this process of evanescence, like an aroma.

The field of heaven, which operates outside space and time, is formed by acts of other entities, other stars and by people who rise in the dark to look for them and place them.

When mind extends toward sky, it may take the form of a perceived star, because respect is a portal.

When your experience ardently links to an object or person where you live—husband, tree, stone—you try to hold on to the visibility of that object and its location.

Connecting with a geometry of sky gives this sense of security, inspiration.

I ally with a meteor crater on the plain, but also with comet light.

2

Venus arrives in cerulean; Antares, second star is just visible, then Pico in indigo.

In full dark, light streaks from one star to another like communication, travel.

My husband beside me sees at his angle, a different array.

Every stream of photons is always there to be seen.

Planets line up and turn with their DNA, energy around them, like a web struck by light.

Stars are holes in the dark; when I look at one, I go there, entity contact easing emotions.

I ask heaven that we be left with some essence of what has disappeared, that one day
we may again experience physical beauties no longer seen.

Remembering concentrates something that works in the present; visibility is like memory.

Dimensions are also; invisible, organizing substrates unify past and present.

They provide a framework that keeps stars in place, cohering the dynamic quanta of infinity,
so travel is easy.

This frame does not emit light, nor other waves, nor show itself by absorbing light from
hot dust or star death, as with a concentrating black hole, nor show how far we extend
into its ecology.

Watching is like living on the mesa, while deepening my reception to it.

Richness I concentrate is not contained; I radiate desert fragrance spontaneously,
like receiving an apache rose I saw in my dream.

May we go to that time; I mean, we'll all see the beginning.

3

She passed on her observations of Venus and spring dawn.

We did not ask the personal details of her study.

We thought, naturally, object and subject processes connect, that night sky and knowing are undivided.

Perhaps creativity is the unfoldment of relations between objective and emotion in space.

The beingness of stars onto which my consciousness projects awe is also consciousness as light.

When we expand into any unknown, we use the term origin, i.e., one time.

Waiting for stars I know is the fullness of time, contingent time.

I go out before dawn to check Venus on my birthday.

I feel extension, pre-space through which dawn will arrive.

There's an ambience of bird song, cicadas.

I aspire for transparent space to diffuse dissonance inside me to its quantum complement.

Sky lightens.

4

I see a white tree against black ground.

Its shape is a person reaching up with wide arms, but fuzzy in outline from leaves and blossoms.

I study how gravity, allure, origin create the shape.

Natural law is represented by the dark from which my tree grows.

Night elicits, then highlights the tree, as if whiteness—day, experience—were a flexible substance being thought into coherence, a mold.

Night is of day as day is transparent, as dark energy is of light attraction.

The tree attains its most intimate relation with black ground in the context of my viewing.

I perceive the beingness of stars as a kind of visually emotive flow-through.

A woman watching is like a mirror surface on the outermost layer of appearance or her experience of the tree.

Each of us when we look at stars is this localized reflection.

I went out with him to see The Spiral branching away.

It viscerally enmeshes us in subtle fields of other beings thinking through space in lines of light.

Distance between viewer and star resolves into one experience, point or singularity.

As you continually generate the transparency of flowing space, it must continually unfold matter that shines.

—Commissioned for the exhibition catalogue Drawing Then: Innovation and Influence in American Drawings of the Sixties, *2016*

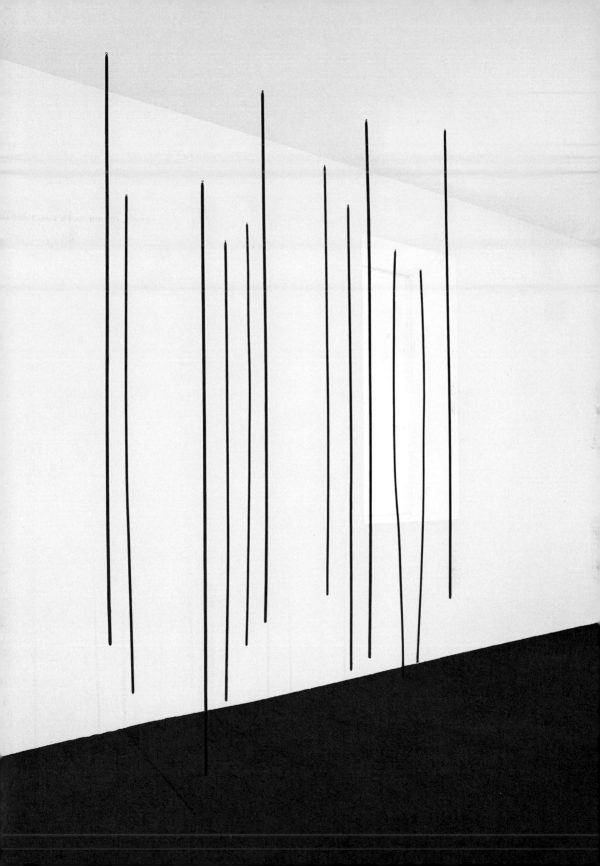

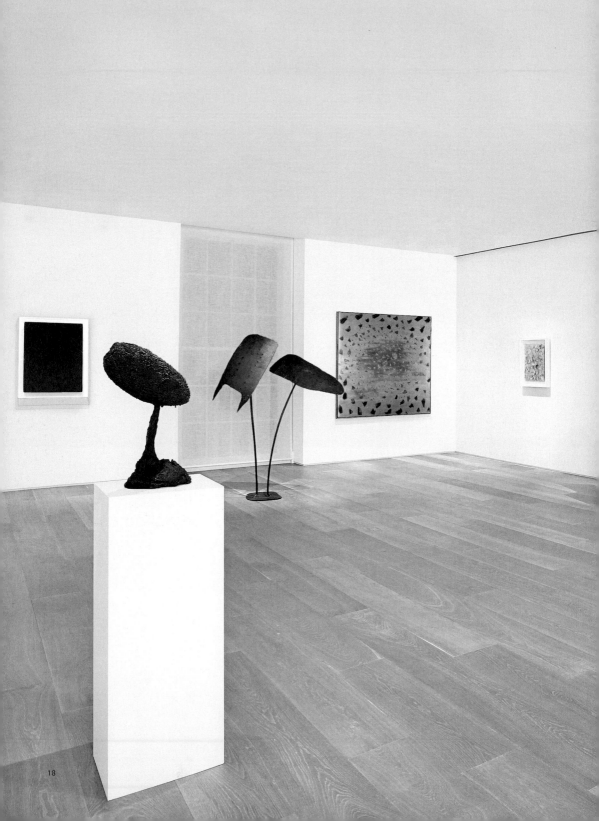

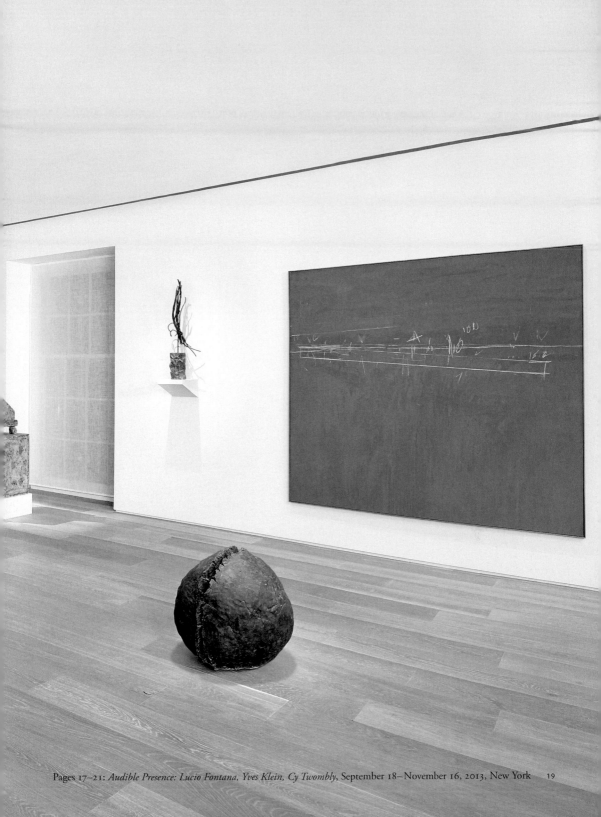

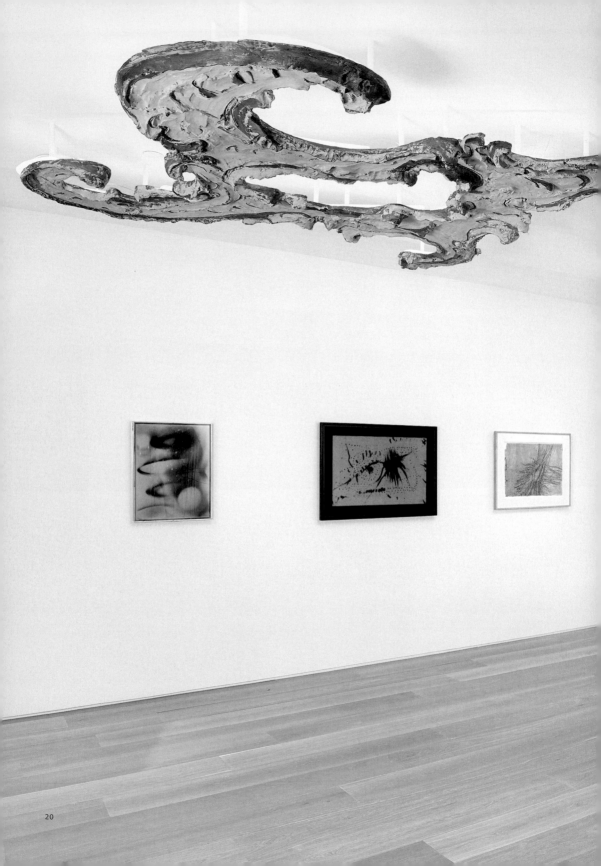

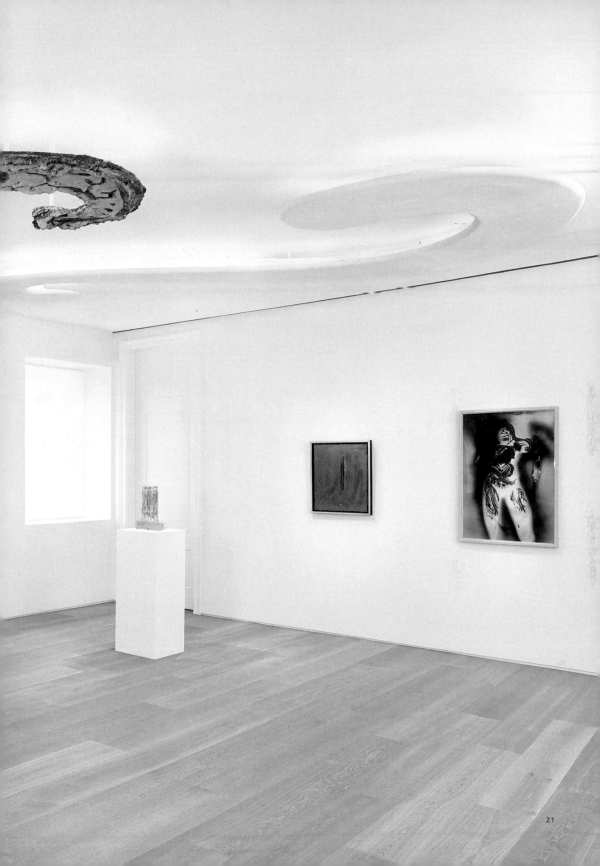

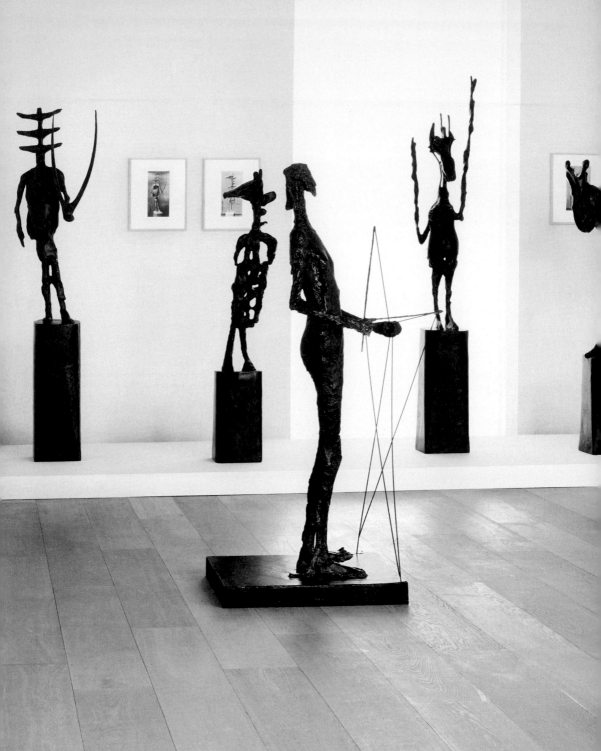

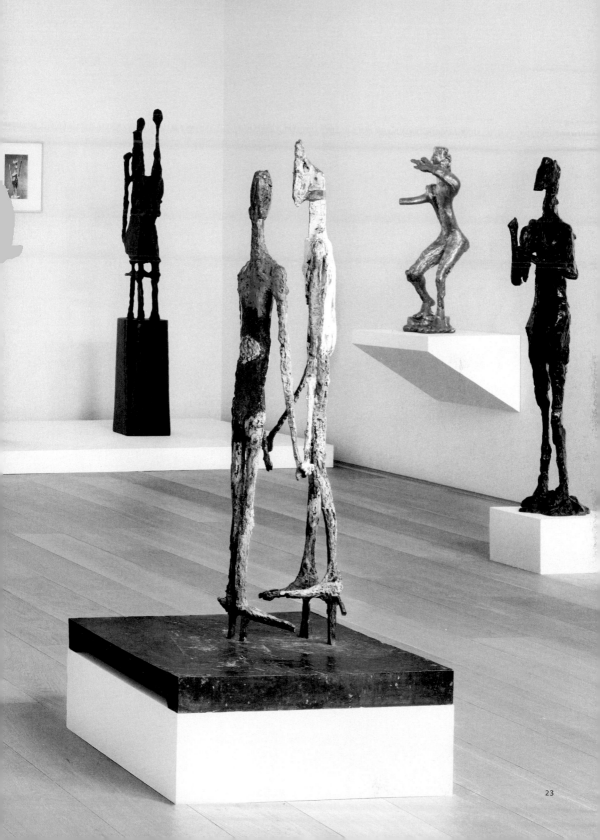

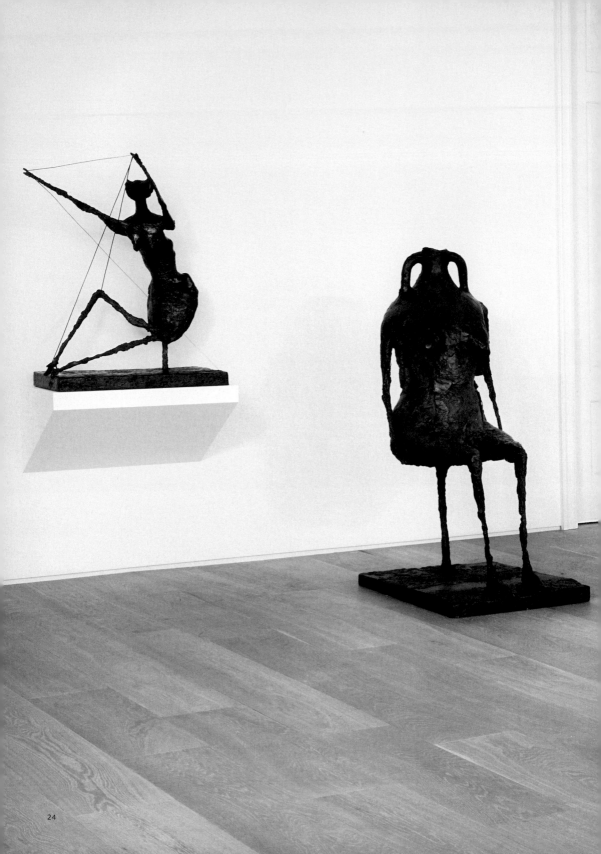

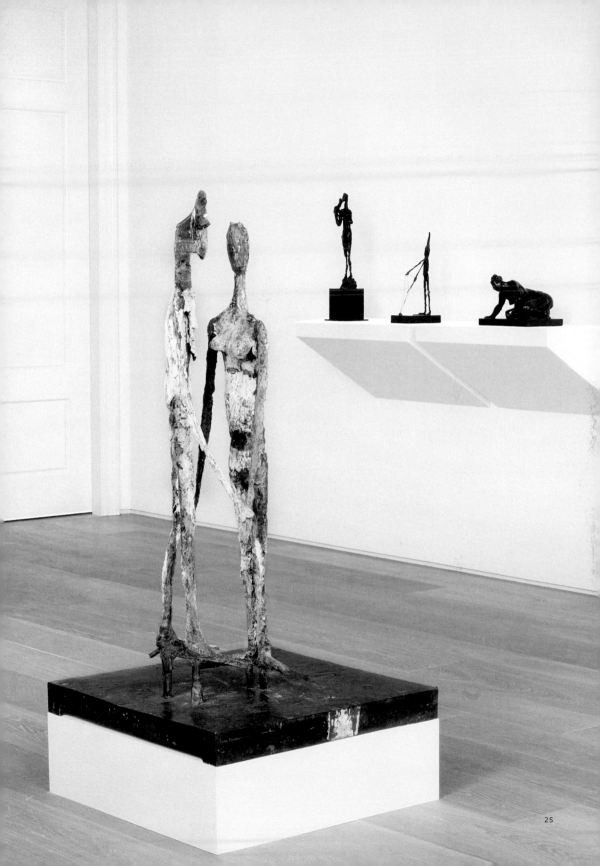

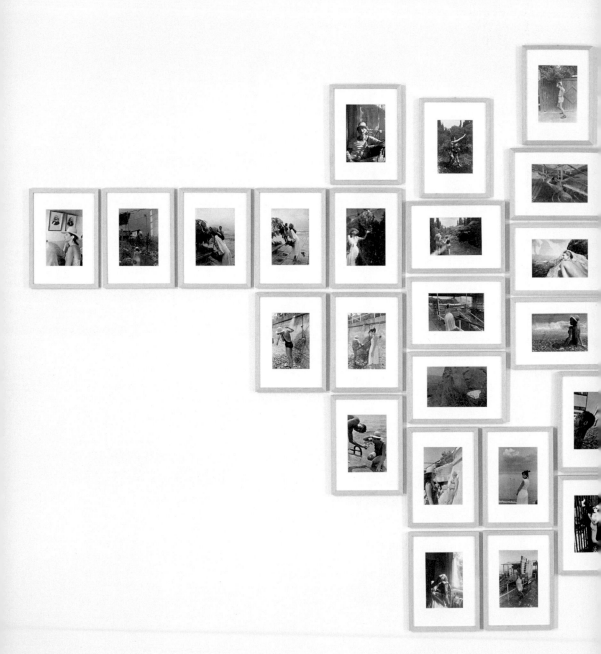

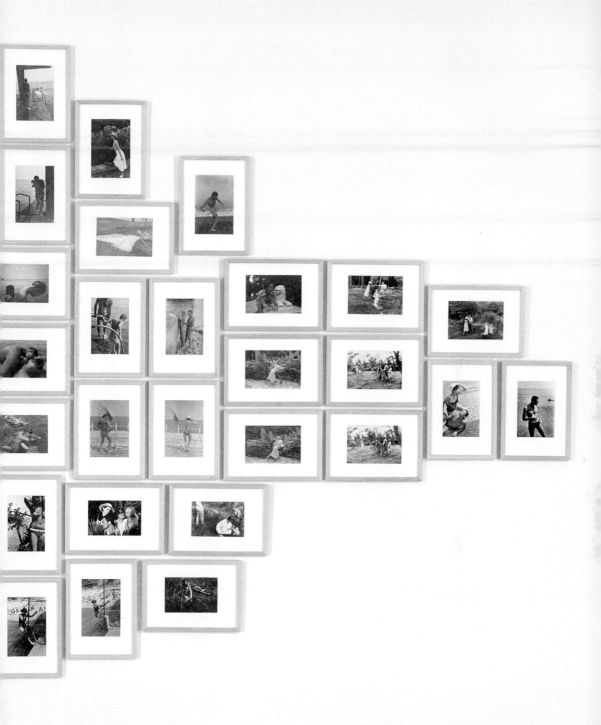

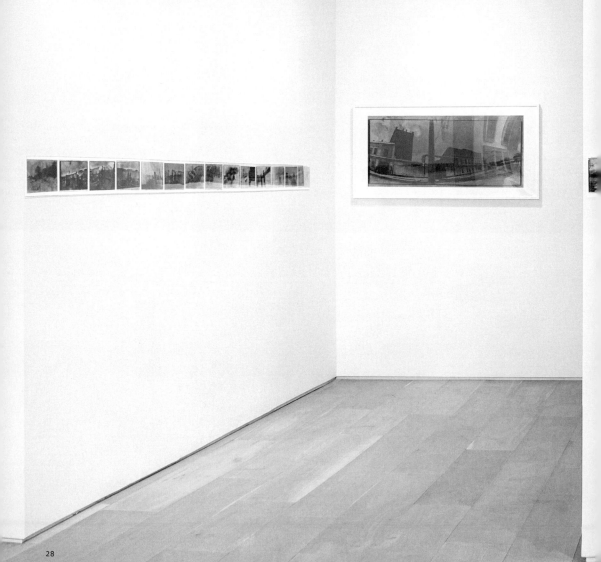

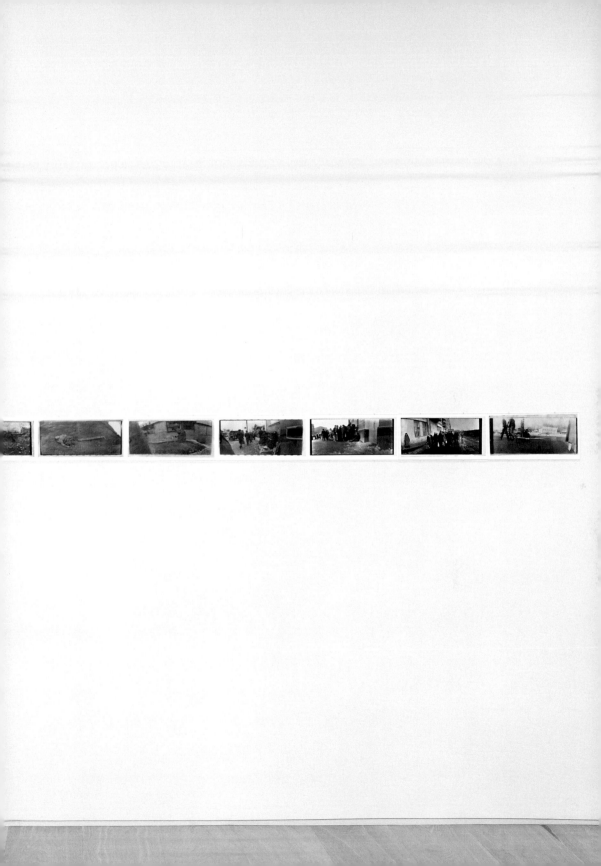

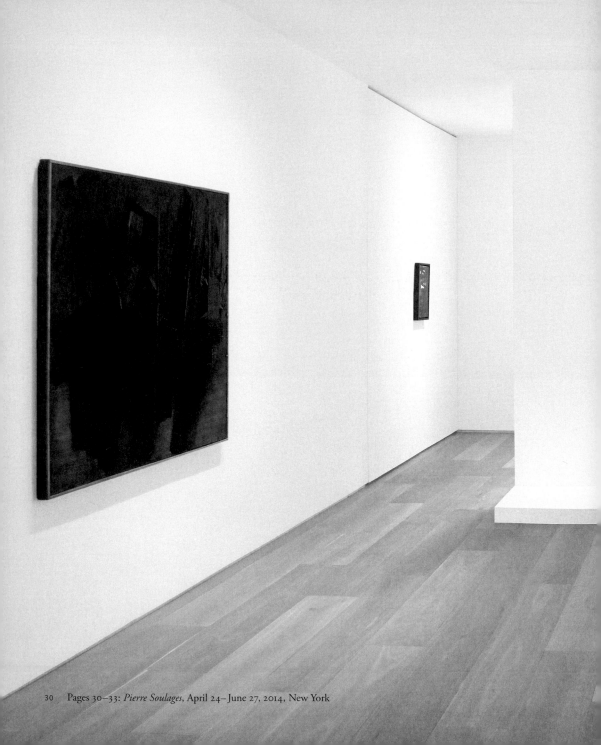

Pages 30–33: *Pierre Soulages*, April 24–June 27, 2014, New York

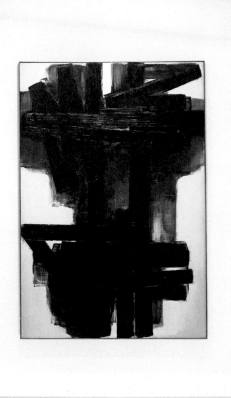
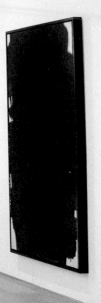

31

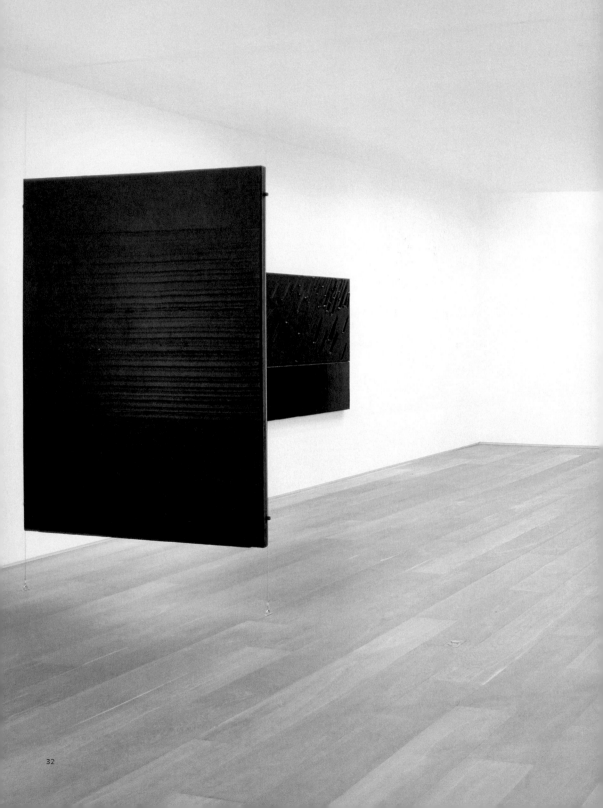

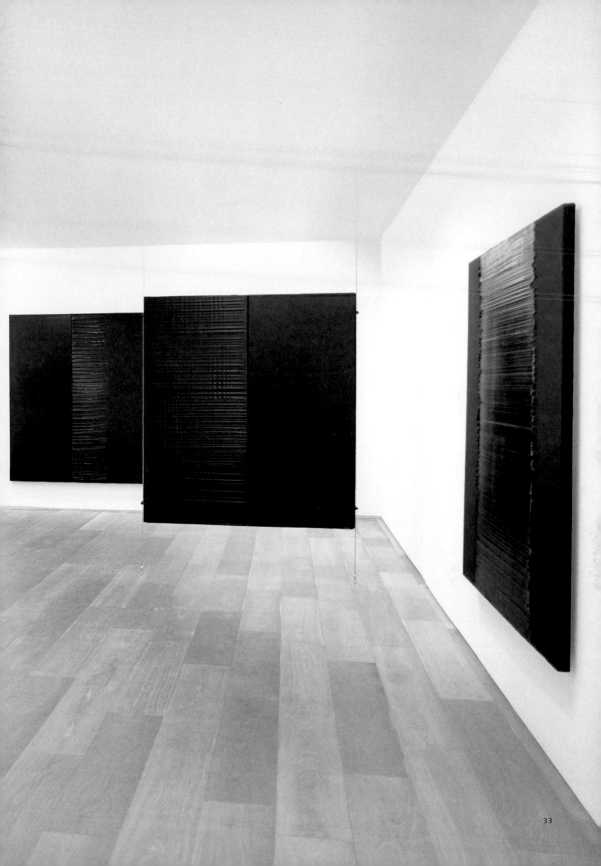

"Hypothesis for an Exhibition", July 8 – August 15, 2014, New York

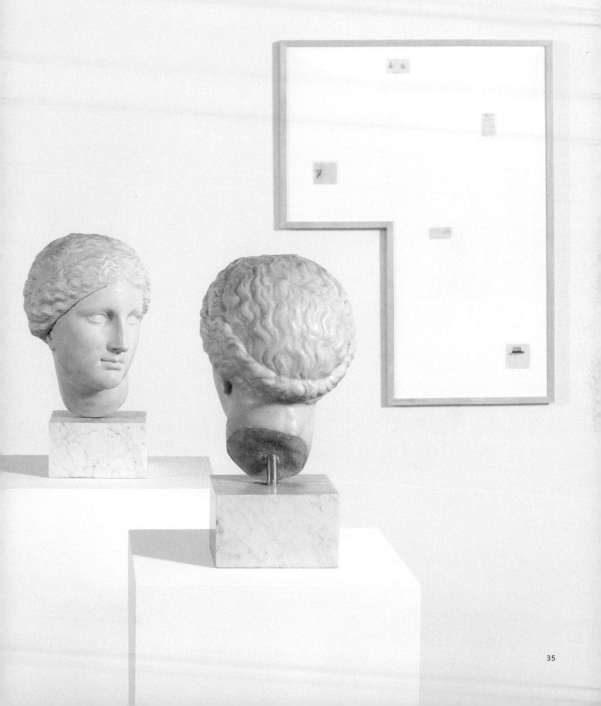

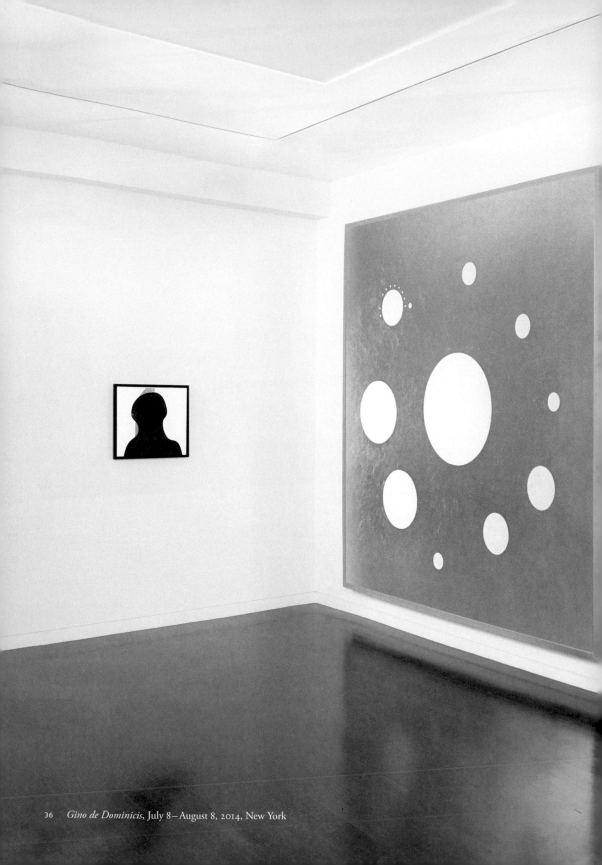

Gino de Dominicis, July 8–August 8, 2014, New York

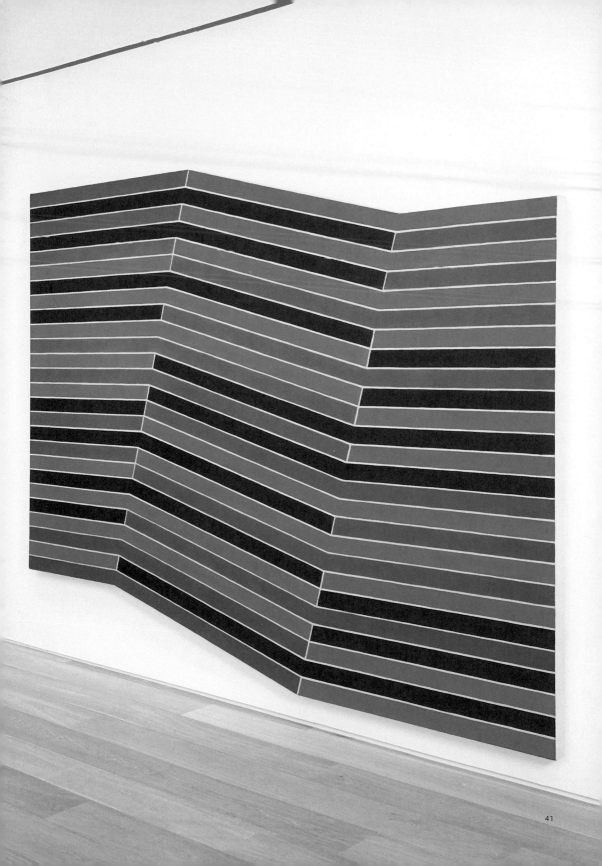

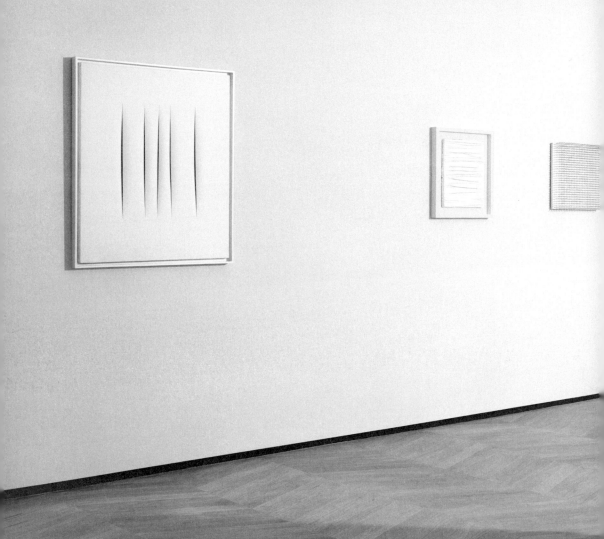

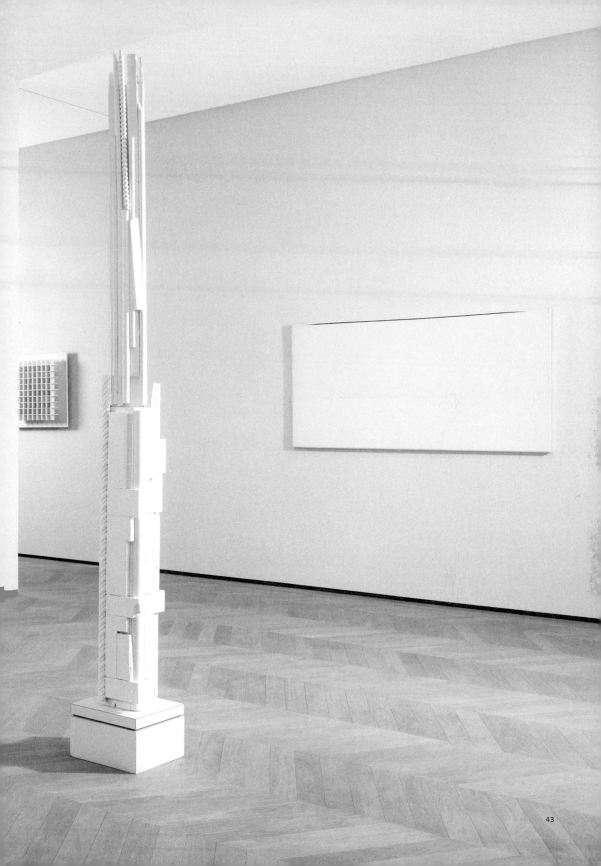

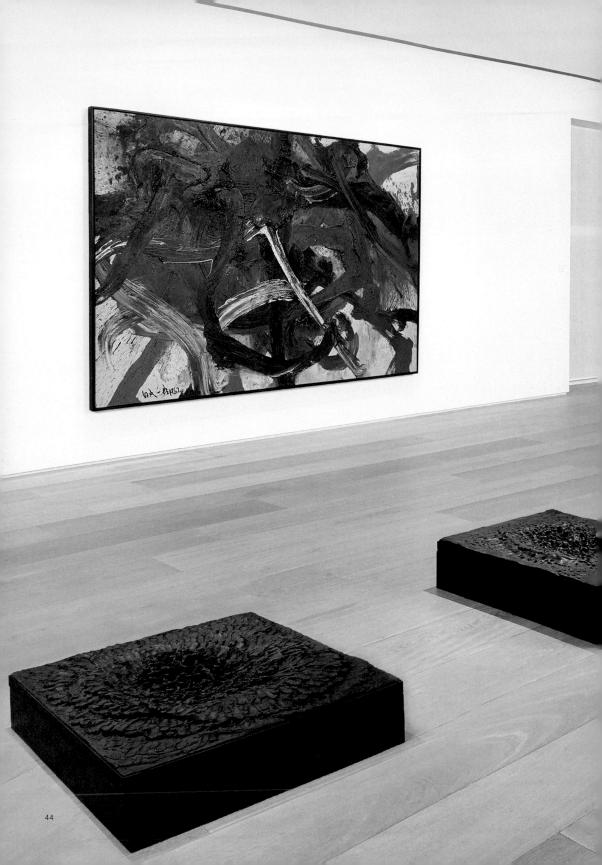

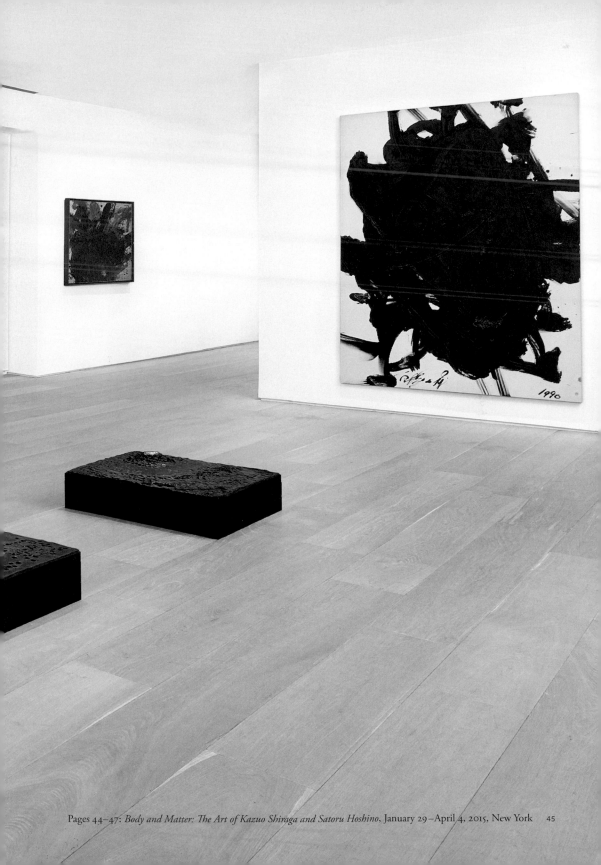

Pages 44–47: *Body and Matter: The Art of Kazuo Shiraga and Satoru Hoshino*, January 29–April 4, 2015, New York 45

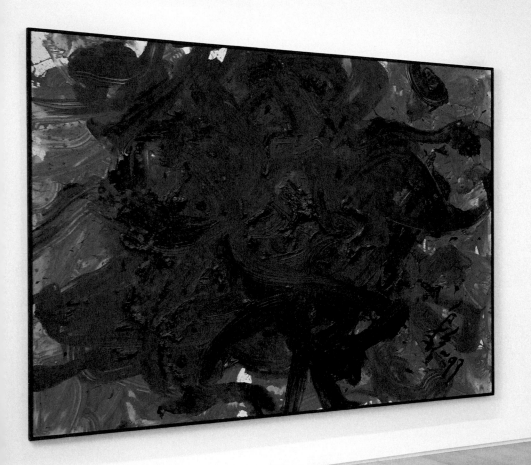

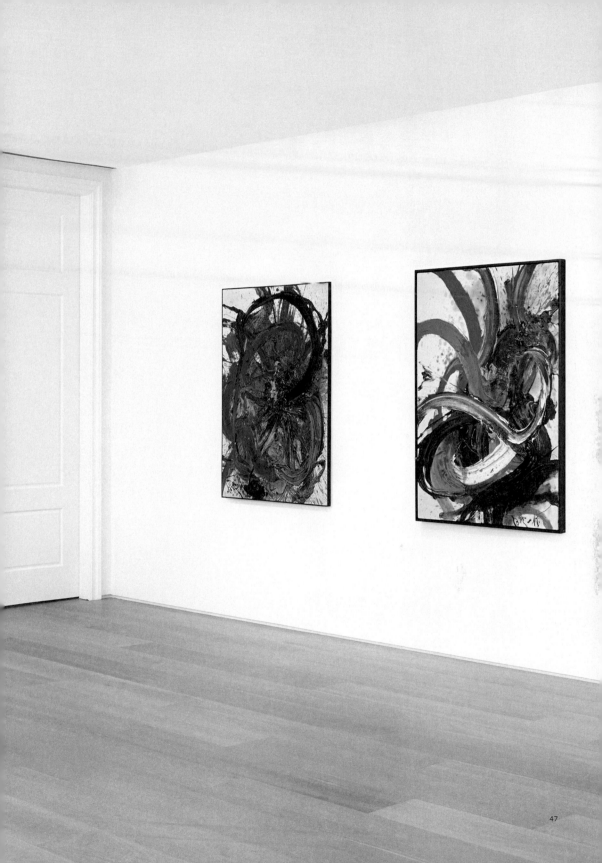

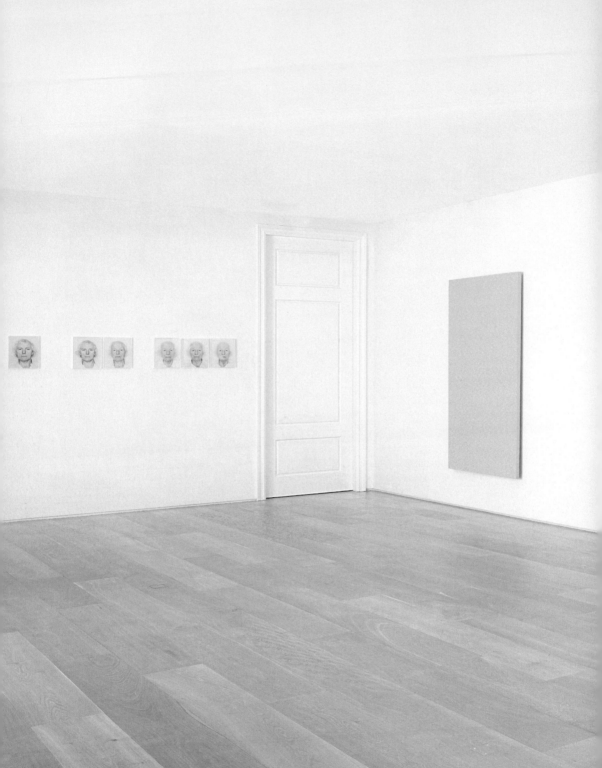

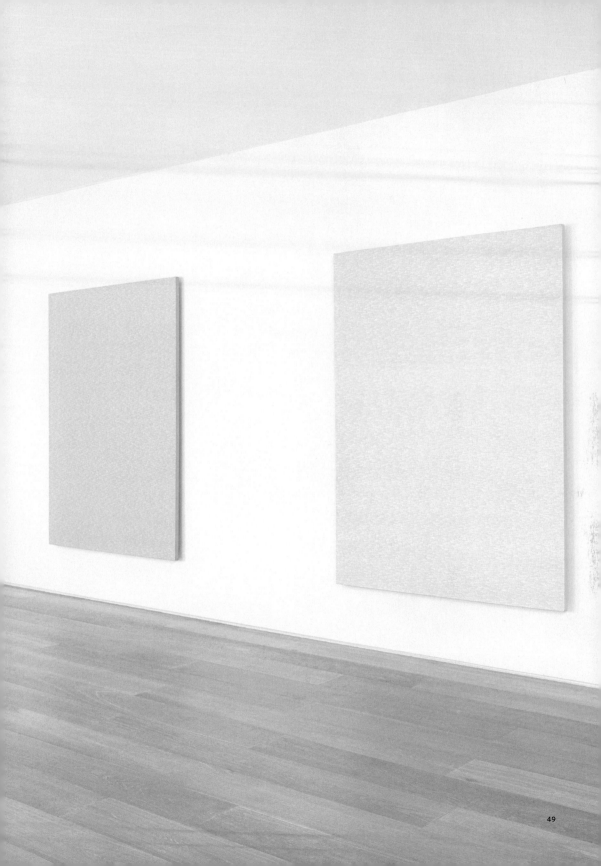

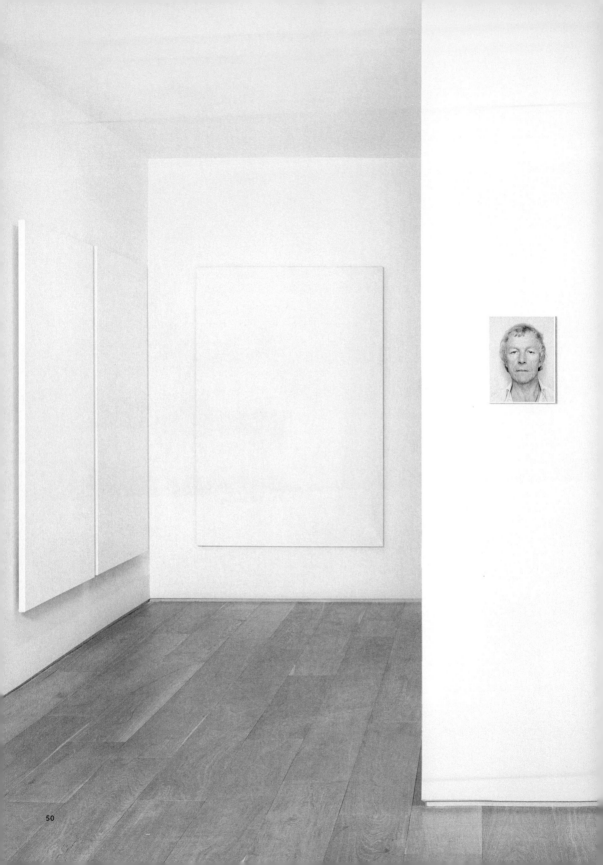

Homage

JACQUES ROUBAUD

If from the atom and germ of
Indivisible unity, each number takes its being as
Successively successor succeeded,
In their spoken, strict advance, the loss
Of substance is obvious and the shadow
Of murky indirectness inert. No one has counted
As far as the million without being lent
What languages wanted to put there
To be substituted quickly in the count.
Only one has made it possible for all numbers
To receive these drops of painted light,
Their difficult share of human reality,
Such, once named, aged, as they are pronounced
By life with its one-by-one seconds

—Translated from the French by Charles Penwarden

Homage to Calder

KARL SHAPIRO

To raise an iron tree
Is a wooden irony,
But to cause it to sail
In a clean perpetual way
Is to play
Upon the spaces of the scale.
Climbing the stairs we say,
Is it work or is it play?

Alexander Calder made it
Work and play:
Leaves that will never burn
But were fired to be born,
Twigs that are stiff with life
And bend as to the magnet's breath,
Each segment back to back,
The whole a hanging burst of flak.

Still the base metals,
Touched by autumnal paint,
Fall through no autumn
But, turning, feint
In a fall beyond trees,
Where forests are not wooded,
There is no killing breeze,
And iron is blooded.

from Kind Ghosts

CECILIA PAVÓN

My life is simple,

It consists of

1) A boy
2) A garden
3) A circle of chairs where people gather to talk
4) A working-class apartment in a working-class neighborhood
5) A refrigerator that doesn't keep things very cold

In the morning, after dropping my son off at school, I read *People* magazine, which
talks about the local entertainment business, while I sip cheap coffee in bars around
the neighborhood of Once.
But I love my life, and my eyes are filled with the sun of the savage third world,
I believe in the old-fashioned and drama—this is why I cry so much—and sometimes
when I walk by the Cathedral of Saint Expeditus, I light a green and red candle and
ask for something,
The other day I asked for peace,

One time three years ago I asked for clarity

I was dating an art critic who had left me, although in reality he wasn't so much
a boyfriend as he was a psychopath.

Every day, I walk by in front of an abandoned market overtaken by rats where
a prostitute sits around, and I think I am the same as her

In the Cathedral of Saint Expeditus, there is a huge metal table filled with lit candles;
as I look at them, I think of hell.

But I love my life and today, this afternoon, I was certain that this book was an elixir

A New Poem

A poet I like speaks of spiritual things

As if they were concrete.

By spiritual things, I mean the devil and the Tribe of Asher and rituals

With fire and cinnamon.

Things like that.

She speaks of them as if they were real,

Without any distance, and that

Is where her skill lies.

She has descended into the pit of death

And has truly met the Enemy—with a capital E—

That is, the devil.

I've also met the devil.

It doesn't matter if it was just a state of mind.

I met the devil.

He was a violent man with whom I lived for a long time.

Intellectuals, too, can be violent

Even if they read Milton and other poets in English.

And what is it in a woman's head that lets her love a violent man?

The poet I'm talking about lives in New York.

Once we presented the translation of her book

Over Skype.

I don't know why I was the one who got to speak with her,

I just happened to be there and was the only person who knew English.

When I saw her appear on the giant screen,

Speaking to her computer,

In her apartment you could see some

Blue sculptures.

I wondered if the devil was still in her house

(As her poem had said)

Or if he had already left and was never returning.

The devil was in my life, too,

For seven years.

He came in the form of a boy.

His name was Fabio, and he had stained teeth.

He kissed me passionately against my patio wall,

The first time that I made him come in.

I confused his unbridled sexual energy

For inspiration.

But the devil didn't tell me he was the devil

Because evil never reveals itself; evil never speaks.

This is something else that a poet told me, in Santiago, Chile,

Héctor Hernández, in a bar called Prosit, one July night.

It all started when I confused the devil for a muse,

That was the problem.

I had believed that Fabio's presence gave me an endless source of energy

Which translated to an endless supply of poems.

I'm unsure why I confused his indifference for

The inexhaustible force of inspiration.

Perhaps because in college they taught me

That in order to be good, literature had to be indifferent.

But I don't want to write literature that's indifferent.

I came from a province and I wanted to be a writer

And I enrolled in a public university,

What else could I have done?

Now, years later, I'm writing this text in a bar

Across the street from Parque Centenario as if I were still the same age as back then.

Outside there is torrential rain,

But what does time matter?

For seven years, I lived with the devil,

I looked after the devil

Blind and submissive to a dark power.

Intellectuals, too, can be violent.

One time, Fabio locked me in the bathroom and when

I tried to escape, he twisted my arm behind my back.

And he did other things to me that I won't name…

The devil resided in my head and in the air in my home

Until, at last, he left.

Now he lives just a few miles away and sends me emails.

I'm afraid of running into him at some event in the art world,

So I avoid even going.

(When I lie down to sleep and I close my eyes,

His mouth appears before me: black and full of snakes.

I immediately imagine his head being cut off,

As an act of protection.)

One time when we were fighting, he told me:

You and your son

Will end up dead inside a resin statue.

Kind Ghosts

Dear Fabio,

The latest developments in our new life:

Do you remember that alcoholic neighbor we had who would shout, "Bitch! Bitch! You fucking bitch!" at me from the third floor every time we lit the grill for a barbecue?

Once—a few days before you vanished—he threw a bucket that hit me on the head and you didn't stick up for me. Now, I'm remembering it, and it seems weird, like you were on his side. His wife came out to argue with me, and you told me that

She was my sister and I had to be on her side. Because she lived an alienated life with a crazy man, and so I shouldn't judge her.

Was this a way of telling me that our life, my life, was just as alienated as hers?

Maybe architecture defines everything in our world, and by living in the same kind of apartment as that woman, with the same dimensions and features, I was the same as that woman.

In any case, Cecilia, Juan Pablo's wife, started working on my patio and garden.

She comes whenever she can, and I pay her whenever I can afford to; we handle most of the work together.

We scraped down the left wall and painted the limestone yellow

She transplanted the orange tree and put it in a bronze-colored pot, and she also planted gardenias,

We moved the hydrangeas and added ferns, lilies, and calla lilies that she brought from her country house.

And we managed to move the grill to the back part of the patio, so the crazy neighbor doesn't have any more reason to scream.

In fact, he looks a lot better lately, like he quit drinking, and when I run into him in the building, he looks put together and well dressed.

He goes out every day to walk his dogs.

Since you left, I feel like my life has been filled with an army of kind ghosts who've come to my rescue.

Kind ghosts aren't exactly people, but the halos of goodness that surround them…
how can I explain it.

These last few months I've tried writing a story about the good and the bad, but I can't get it out.

Other things that have happened to me (in case you're interested at all):

A playwright sent me a copy of his book called *Everything Would Make Sense If There Were No Death*. I liked it a lot; it scared me and it made me cry. It had sex scenes that aroused me.

A painter brought me her first book of poems called *Vigil and Velodrome*, and she asked if I would present it.

On the day of the presentation, at a place on Bonpland Street, I said life was a chaotic enumeration and that the key to success lay in the fact that, between each pair of commas, the author has instilled a dose of forgetfulness.

In reality, my presentation was a direct quote from a book by César Aira called *Biography*.

Later on, the character in *Biography* says something about observing the ecstasy of the world, and I loved it.

There's a new boy in my writing workshop who studies philosophy and I think he's a sage; he always talks about unconditional love. He's rich and his poems are always set in Puerto Madero and Punta del Este, but everything he says is so potent that it doesn't matter where it takes place…

I don't know where you might possibly be, because we haven't heard anything about your life ever again…

Yesterday, Francisco asked me if I wanted to publish something through his press, and I realized that a poem can be like a letter, like a bottle thrown into the sea, like a sparrow's small gray feather floating in the ether

That's why I'm writing you this update now

Perhaps some day, by some stroke of chance, this chapbook will end up in your hands and you'll read my message.

And you'll realize that all those years we were together, the only thing I ever wanted,

All I ever wanted

Was to move you.

To move you!

Yes,

Even if it may have been a ridiculous idea,

I know that I tried it.

—Translated from the Spanish by Jacob Steinberg

Materia 0

JOEY DE JESUS

u weep in the heat of a dark
duttiwine, wepa in a seance
euphoric and burnt grass
thrusts upward in the chest.
u pledge to the complex
chemicals of body odor,
a game of hips, odor
of ur dark genitals...u dab. a dark
battybwoy duttiwines the complex
movements of sparrow's chest.
a sacarla moment of vigilance
is a mouthful of sparrowgrass.

u don't call it *grass*
though u waft in its dank odor,
keep big nugs in a tin chest;
stardawg triggers a dark
cosmic vision, imbalance.
ur relationship is complex.
he's white w/ a papi complex
and ur the dead grass
he finds in his mattress. u dance
ur unplanted foot, odorous,
less person because u are dark
less so because he is chesty
less so because he has a chest
and u love ur complexion.

u melodia a lexicon in the dark.
he turns and u turn into grass
unearthed detritus nitrate odor
—abeyance, a grass trance.
u thrust ur spirit like a lance
through his muscled chest.
ur muscles mouth an anti-ode,
a boy's battalion complex
u hiss. doing ur grass
dance, now alone in the dark.

u weep—

Materia IX

JOEY DE JESUS

> …ophiuchus archived
> …spectral edge
> …
> …

axiom:

as the palaver of a lover in whose lip
-service i spent several years,
i've been fasting for six nights
bawling ur epithets eighteen nights
and you have forsaken me
ten months

naked & journaling
cosmologica, two flaming star cores
spin an aeon toward collision

a million times turning a million times
an entire galaxy, arms outstretched
along an azimuth to no one

dark vault engaged
with that which would destroy it,
u lift my unstructured
sentences to ur colossal haven
for the selves slain and offered
to your light furnace

not even the dimmest lyric
echoes from my torso,
which confirms, i am only
a voice beneath the shadow
of death. & i am
out of time.

autosacrifice

JOEY DE JESUS

for my mother

*Casie is a 26-year-old widow who, following her husband's premature
death, became addicted to eating his ashes. Her story aired on the season finale
of* My Strange Addiction *in August 2011.*

This is how I've kept
my time: tawny and allied
with leopards, waylaid
in my inmost shrine, no
refuge among planetary
spirits star-fed crystal and ice.

The Saint of Lourdes,
My mother's namesake,
for weeks stomached
mulch, stonecrop, true
forget-me-nots for a
of pure water.

Can my voice roil rage
into trapspirit agua? Is
the warlock gift of poetry
the only escape
from this prison of the self?
To commit honest mistakes,
devote into soot river—lip
of anticipation, of insistence

—Mom, do you understand
your children?

How we whet our appetites
against implacable earth?
What we must eat
in devotion to wherever
we must go.

Artist Statement #2

TRUCK DARLING

All paint is war paint when you're newly stretched.

Nude of grace, I want to be seen with dignity or not

At all. A plumeria lei is all the Ethers will allow,

Fractional ownership of grief only. I take the candor

Of the animals as birthright, baby gear. It's 5 a.m.

In the morning inside the heart. Outside, the *constantly

New darks.* Pulsing with winks, I'm almost awake. Getting

It together on a tract of peat marsh swamp, a trophy

For atrophy at great speed. I will not award this momentum,

Nor tag this "over." I have no energy for down below. Close

To throbbing, I can still swim like this in THE AMERICAN TUB.

If you're still mining for hearts of gold, visit the expert,

The exposed sleeve, with its apotheosis part, "sling." No

Matter how warped I see the world, it's my world, cracked

& salty. Nude of grace, I paint it anyway.

Artist Statement #3

TRUCK DARLING

For serious, the dispossessed inherit the earth.

If you're not dispossessed, why make art? Creation

Seems so old & boring & not paintball. As long as

I keep doing what I'm doing: dragging images in my head

Into the light, we'll be alright. I remember the 1st time

The heavens moved, baby trapezoids & sungrowth over & over

Again. The skate park does not know it is a heaven, the new,

The free, the unconstructed work of God. You defeat me. I

Want to live with you. You open the screen door, voluptuous

In morning. The concrete surfer in the Delft-blue dawn

Carving streets is rude & sick. The town looks like it

Vomited up mackerel flophouses & kids with birthmarks

On their face. 1 of the more punk things you can do is

Be aggressively aligned. I buckle my helmet, fall in love.

Stretching Canvas

TRUCK DARLING

The birds will be worried if I've forgotten

Something so I index works of art with windex.

I've an eye for qualities common to primitives

Since I'm mostly nostalgic for the prelapsarian

World. I want to apologize but I don't know what

For. My whole Edenic life has been mightily devoted

To Apologetics. Like a child's clothes forced on

An adult's body, the royal condition was explained

To me through stepwork. On a typical day I could be

Skipping prayer, I could be out for oysters or I

Could be at home coloring outside the lines. When

I have gone from clean to slurping bloodies, I now

See double I mean twice as many maggot larvae not

Oreos on the Hospitality table. Breakfast, Lunch &

Dinner, pureed & sweet in the hollow pit of marrow,

Osso bucco: the nausea of not knowing God as shocking

As a dyslexic dizzied by a flurry of swastikas bordering

Asian eternities, or a dune buggy going nowhere while

A diabetic dangerously fingers the Milky Way in a dark

Aisle seat. No, I said I don't care for anything to eat.

I'd prefer a seasoned presence, a crisp stretcher,

An heiress with injured boating ankles. I wish my ex

Would overnight a wilted bouquet of turd blossoms

From his concrete bunker in Mexico. I wish I could burn

My history but instead I model with the furniture so

You can see what comes with the crowded past. By the 4th

Step things start to explode when taken away. I may shut down soon but

I have an emergency generator called Belief in Art &

The bloodwork of a ten-year-old. Pick the insects off my body

Of work before my fam arrives for the viewing. The real thrill

Is discovering how little love you need to get by. Maybe I can

Leave the page since my heart lives on inside a baby. Now they

Won't even show you the baby at the viewing, only describe it.

Abstinence selects my sadness sluttily. I'm going home now,

Swerve more than average on the interstate, limp away well

Composed without sobbing. Wow.

GEGO

ANNE TARDOS

I

The accidental concurrence of a poetic and artistic thought.

 Where lines intersect lives.

Where language intersects reality.

 Where knots are tied to hold it all together.

 All ~ *Alles* ~ *das All.*

All is subjected to the rules of the universe which contains all.

 Quiet observers, we gaze at the world thoughtfully.

II

A line in a poem addresses a line in space.

Moved by the urgent desire to establish a structural system,

 she creates a space where reason rules.

She keeps it clean. Even cleaner.

She delights in making it.

Geometry and physics inspire purity of heart.

 She draws a fine line between a fine line and a fine line.

III

The hand becomes the tool of a distant sphere.

Using lines to delineate, the artist's hand reaches into space and

 comes up with a whole new space.

Strategic distribution of mass...

 Vertical ground reaction forces...

 Flexural stiffness...

Continuous fields let air and light into an open system, implying

 infinity, demonstrating thoughtfulness.

Points in space-time become the joints—recurring points of

 departure.

IV

The artist enjoys this.

"Just doing."

Life is to be enjoyed, she says. If not, then why...

She works "by reason of making," yearning to extend what

 she already knows.

She doesn't know where it comes from.

Yet with each line she draws, she knows there are hundreds more

 waiting to be drawn.

She points to the charm of a line in space.

The humanity of a line—"line as human"—profound love for

 the human being.

You could say that the structure becomes a metaphor for

 a historically inflected life.

—Commissioned for the exhibition catalogue Gego: Autobiography of a Line, *2015*

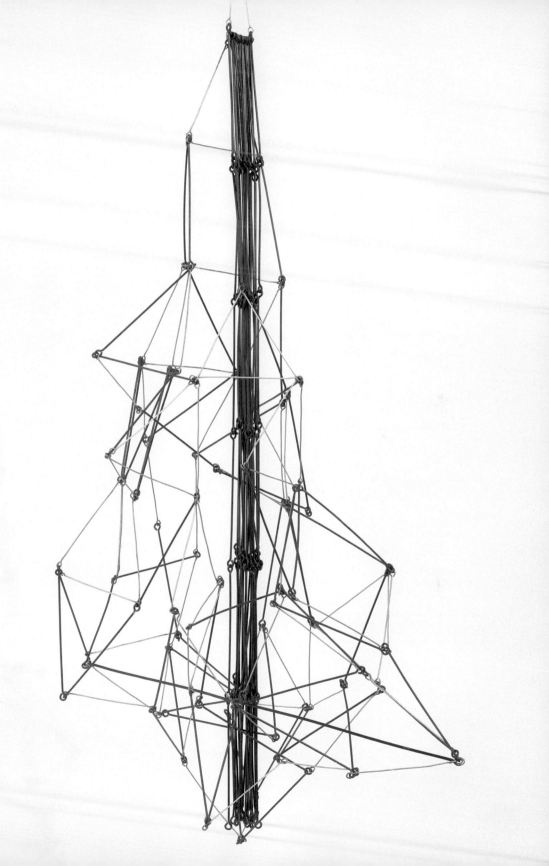

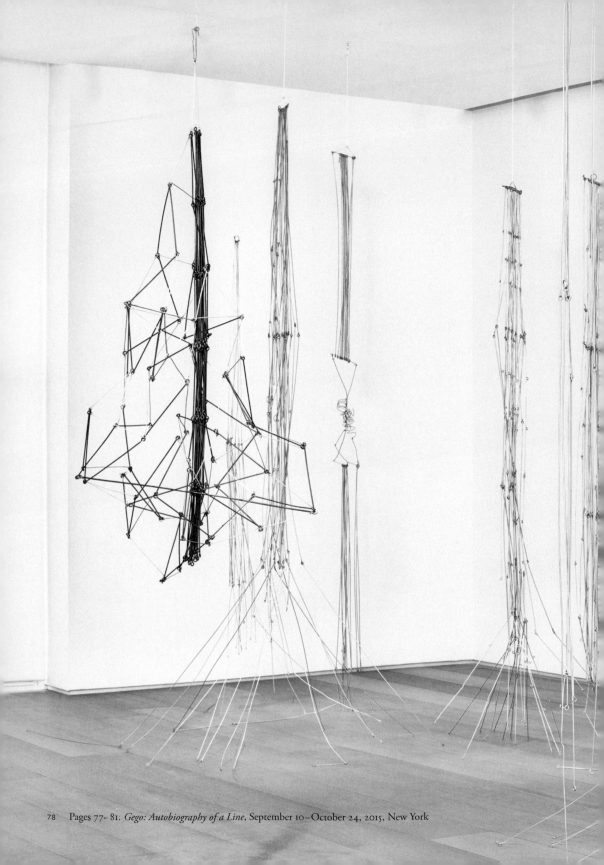

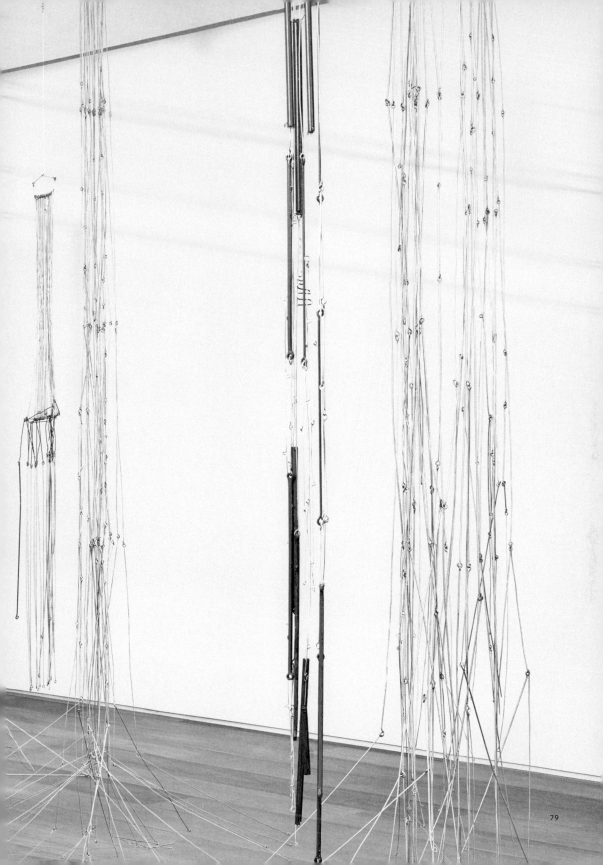

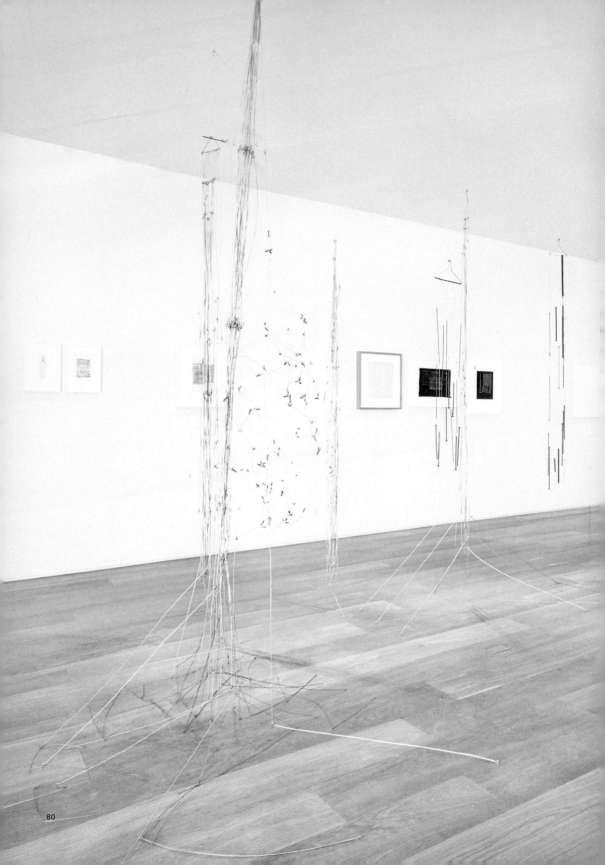

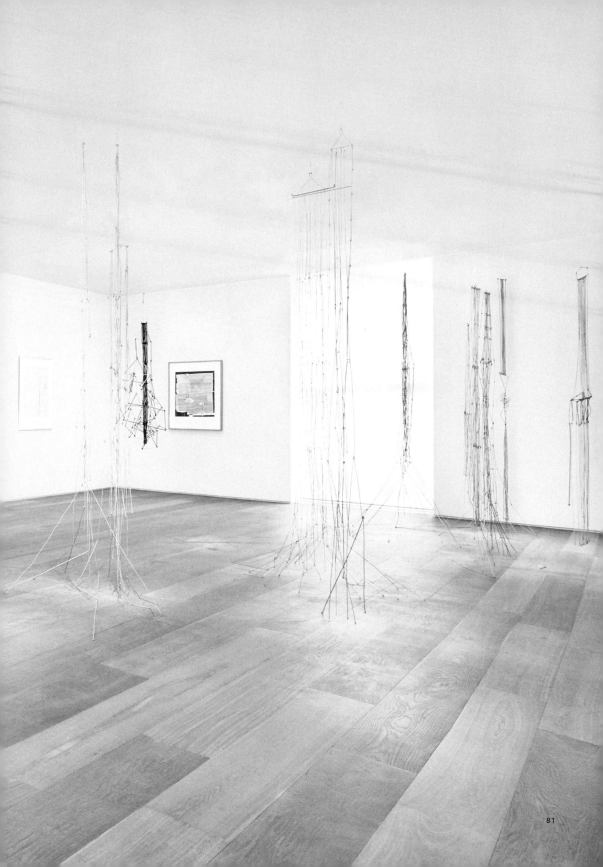

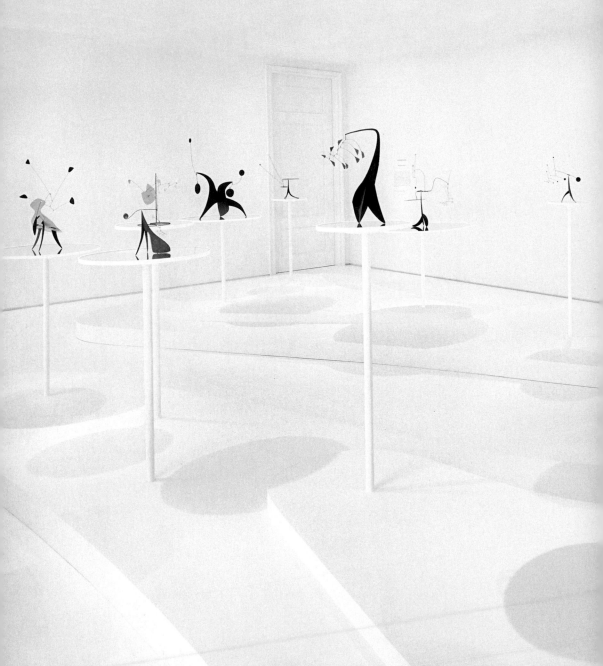

Pages 82–85: *Alexander Calder: Multum in Parvo*, April 22– June 13, 2015, New York

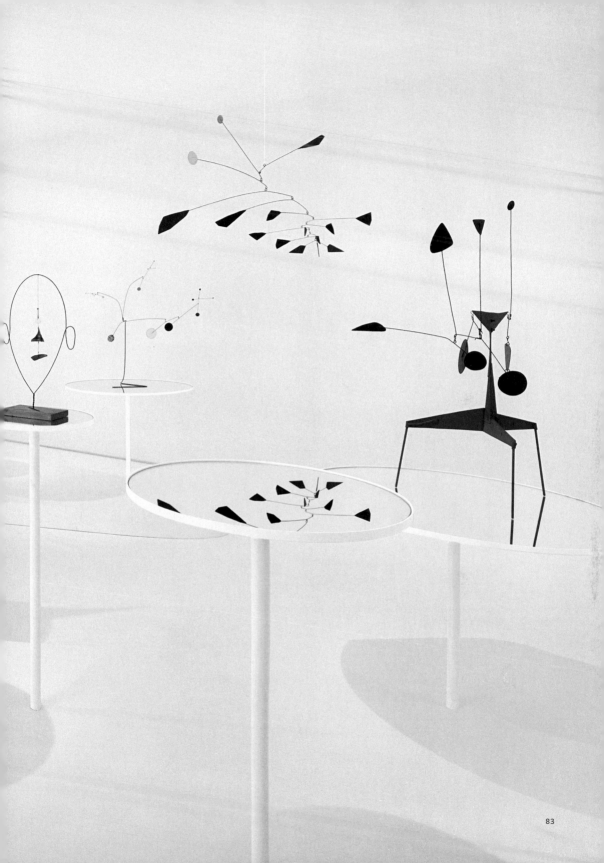

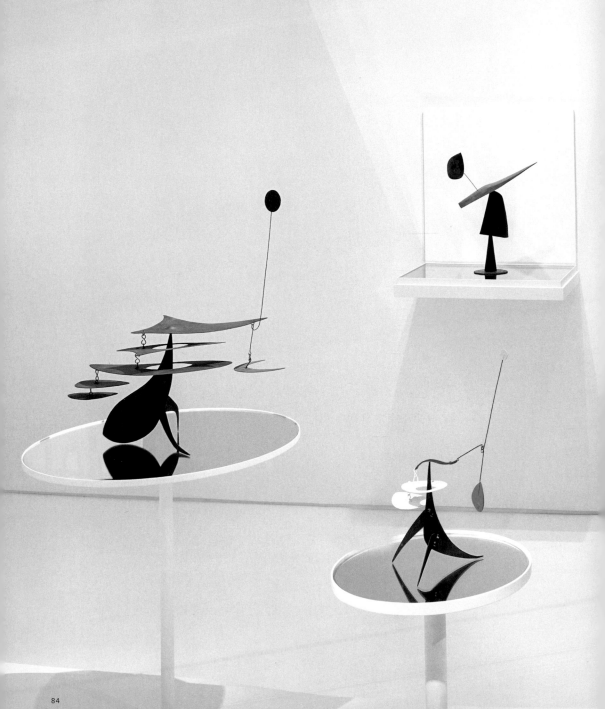

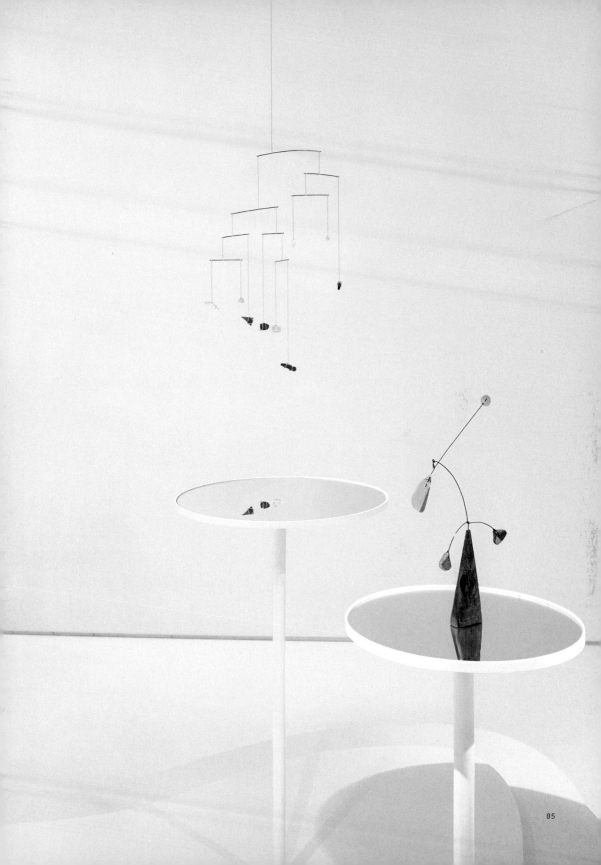

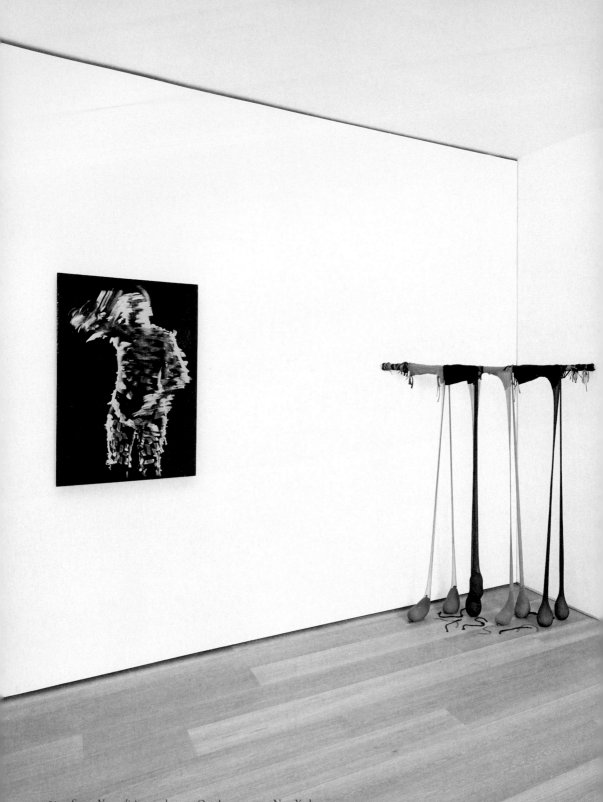

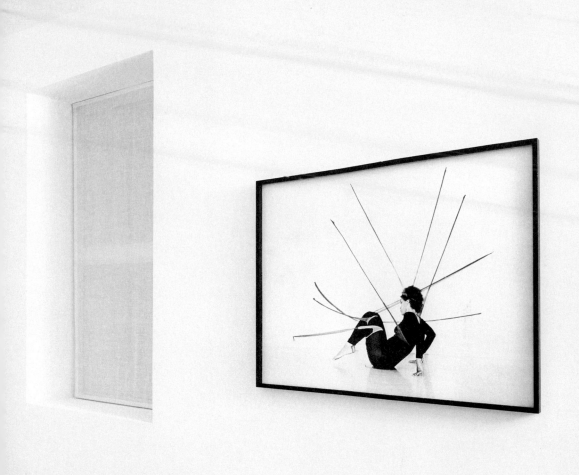

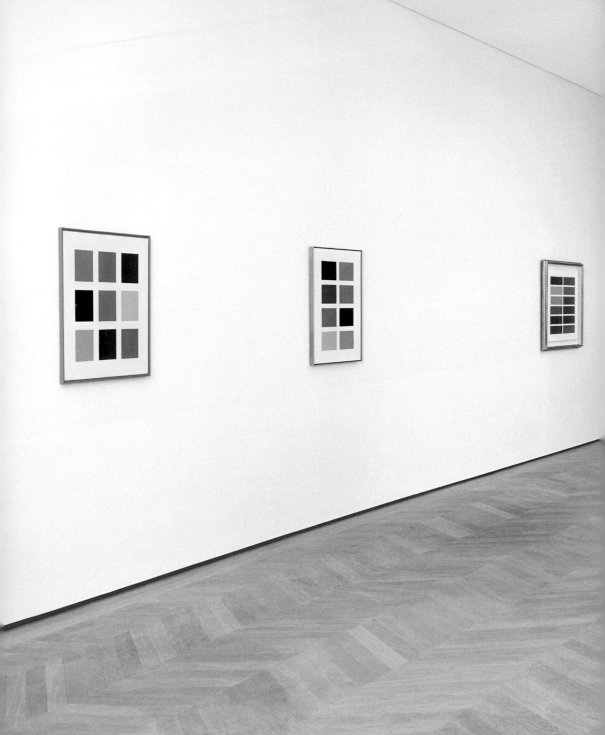

Pages 88–91: *Gerhard Richter: Colour Charts*, October 13, 2015–January 16, 2016, London

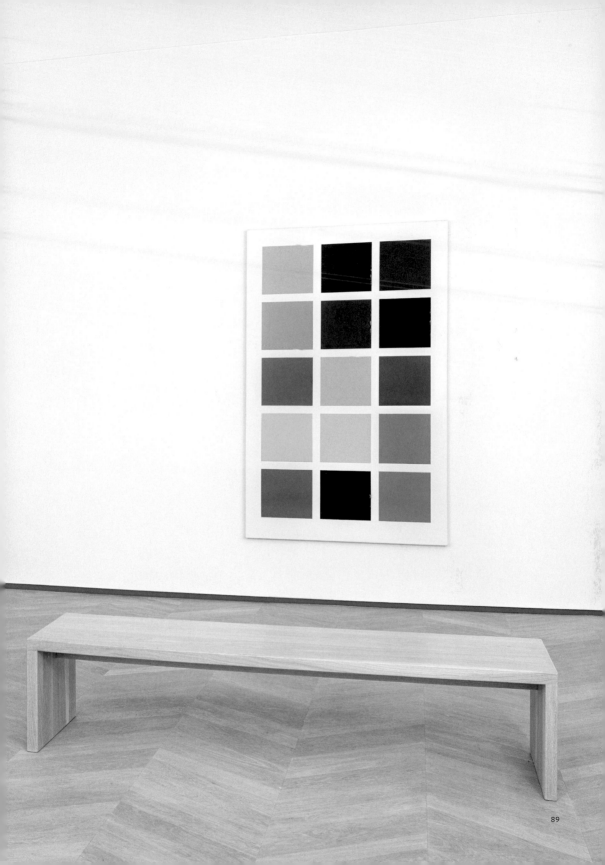

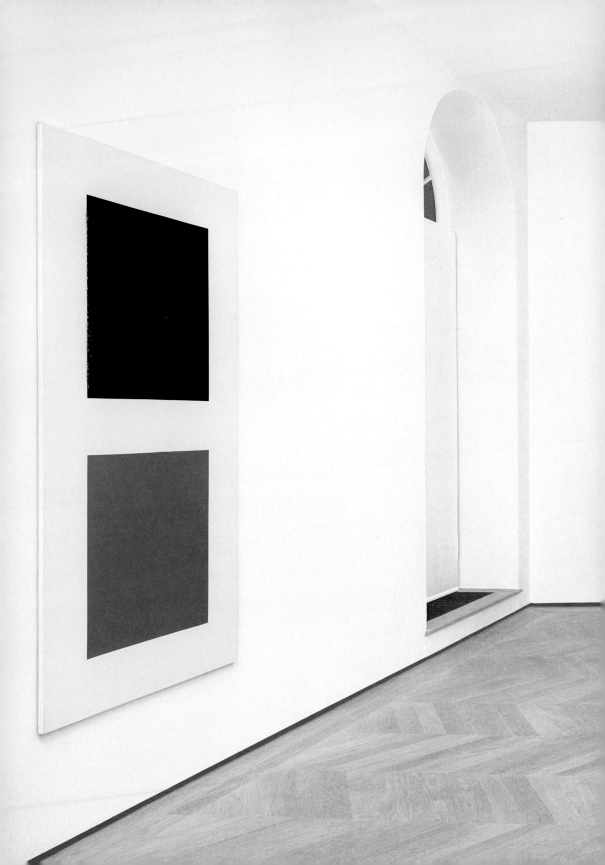

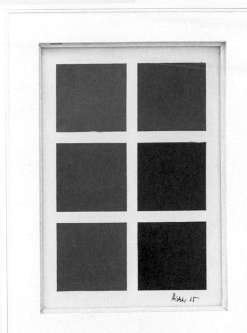

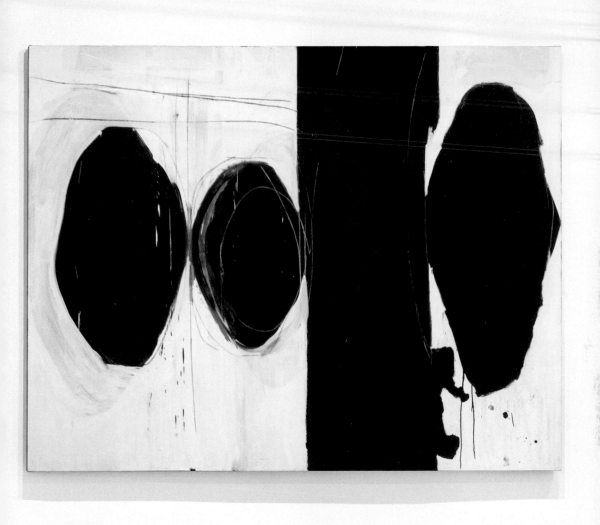

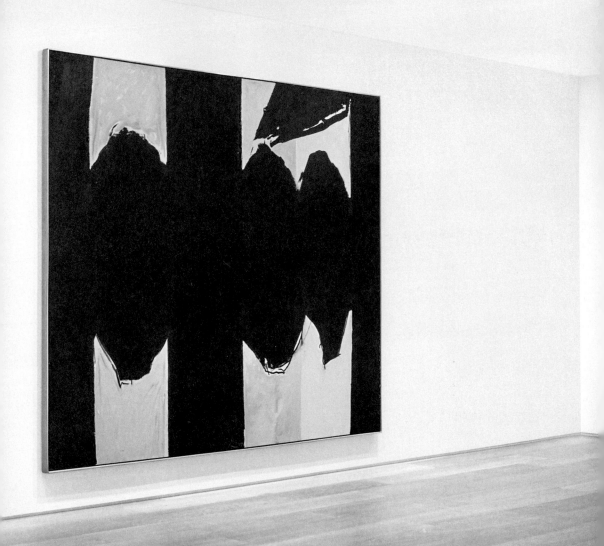

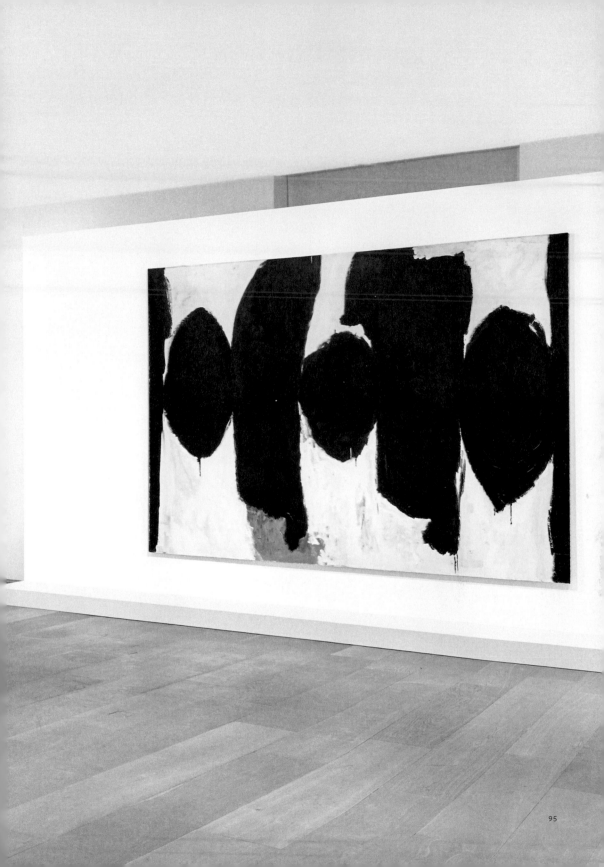

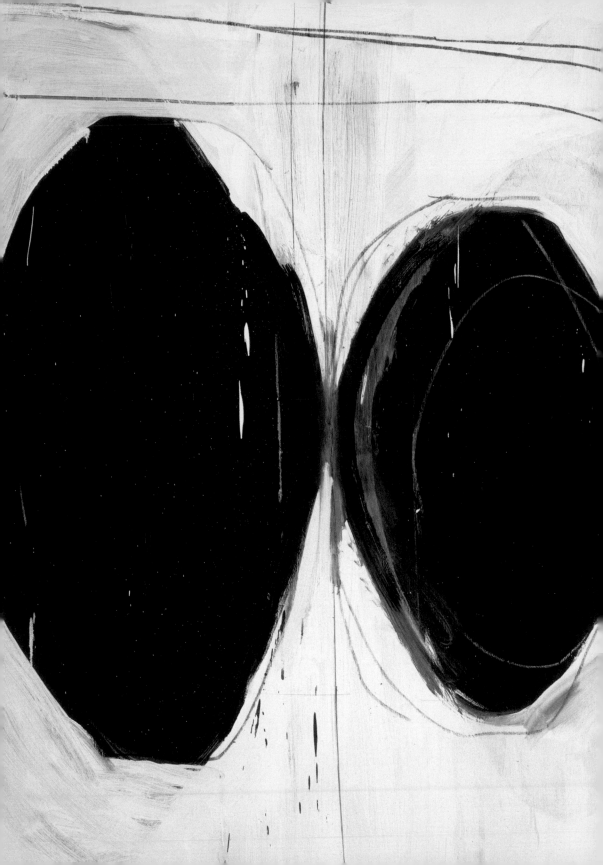

All Elegies Are Black and White

BARBARA GUEST

To Robert Motherwell

When Villon went to his college
he wore a black gown
he put his hood up when
he went out on the black streets.

He ate black bread
and even drank a kind of black wine,
(we don't have any longer)
it wasn't that good Beaune
his skill taught him how to steal,
a disappearing drink also.

The sky was white over Paris,
until it fell in the streets,
like a sky over mountains,
disturbing and demanding.

When you are in Spain
you think of sky
and mountain where the forest
is without water.
You think of your art
which has become important
like a plow
on the flat land.

There are even a few animals
to consider.
And olives.

Do you regard them separately?
The forms of nature,
animals, trees

That bear a black burden
whose throat is always thirsty?

I know of Seville of black carriages
one factory
one river
the air is brown.

Alas we have fair hair, are *rojo*.

Throw a mantilla over your face
rojo of the light,
walk only in the white spaces.

The trains that cross back and forth
the borders of Elegy
sleep all afternoon, at night
lament the lost shapes.

I think when you oppose
black against white,
archaeologist you have raised a dream
which is bitter.

The white elegy
is the most secret elegy.

One may arrive at it
from the blue.

The sky in Spain is high.
It is as high as the sky
in California.

When one begins with white and blue
it is necessary for one's eyes to darken.
One may have fair hair in Spain,
yet the trouble of blue eyes!
Unless one can always live
sparsely as in Castille.

(How wise you are to understand
the use of orange with blue.
"Never without the other.")

And what courage to allow oneself
to become black and blue!

It is necessary that eyes be black
so the white may deepen
in them the white may sink,
it can then be constant, as music
is constant, or a marriage, or fountains,
or a palace whose shadow is constant.

To make an Elegy of Spain
is to make a song of the abyss.

It is to cut a gorge into one's soul
which is suddenly no longer private.
This privacy which has become invaded
straightens itself up, it sings,
"I am proud as a cañon."

Can you imagine the shock over the world

against which two enormous black rocks roll

this world that looks like a white cloud

shifting its buttocks?

 When the guitar strikes

A procession of those tasters of ecstasy
the thieves of dark and light
beginning with Villon

whose black songs are elegies
whose elegies are white

 Dios!

A Bird for Every Bird

HAROLD ROSENBERG

I said to him: Why do you delay?
He said: Because of what you desire.
And I: <u>You</u> command my desires…
So sweetly the argument went on from year to year.

Meanwhile it was raining blood and rage.
　　The two Marquis, the white and the black
　　Were crying like gulls out of my throat—
　　My throat uncaring as the summer sky—

All to avenge themselves upon the dust.
　　Leopards drowsed on the diving boards.
　　I knew who had sent them in those green cases.
　　Who doesn't lose his mind will receive like me
That wire in my neck up to the ear.

Lament for Ignacio Sánchez Mejías

FEDERICO GARCÍA LORCA

To my dear friend Encarnación López Júlvez

1. THE GORING AND THE DEATH

At five in the afternoon.
It was exactly five in the afternoon.
A boy brought the linen sheet
at five in the afternoon.
A basket of lime standing ready
at five in the afternoon.
Everything else was death, only death,
at five in the afternoon.

Wind scattered bits of gauze
at five in the afternoon.
Oxide sowed glass and nickel
at five in the afternoon.
Now the dove battles with the leopard
at five in the afternoon.
And a thigh with a desolate horn
at five in the afternoon.
Now began the drums of a dirge
at five in the afternoon.
And the bells of arsenic and smoke
at five in the afternoon.
Silence gathered on every corner
at five in the afternoon.
And the bull alone with lifted heart!
at five in the afternoon.
When sweat of snow began
at five in the afternoon,
and the bullring was drenched in iodine
at five in the afternoon,
death laid its eggs in the wound

at five in the afternoon.
At five in the afternoon.
At exactly five in the afternoon.

The bed is a coffin on wheels
at five in the afternoon.
Bones and flutes play in his ear
at five in the afternoon.
The bull's bellowings stay at his forehead
at five in the afternoon.
The room turned iridescent in his agony
at five in the afternoon.
Now in the distance gangrene appears
at five in the afternoon.
A white lily in the green groins
at five in the afternoon.
The wounds burned like suns
at five in the afternoon.
And the crowd breaking the windows
at five in the afternoon,
At five in the afternoon.
Ah, that terrible five in the afternoon!
It was five by all the clocks!
It was five in the shade of the afternoon!

2. THE SPILLED BLOOD

I don't want to see it!

Tell the moon to come,
for I don't want to see
Ignacio's blood on the sand.

I don't want to see it!

The wide-open moon.
A horse of unmoving clouds,
and the gray bullring of dream
with willows at its *barreras*.

I don't want to see it!
Remembering burns.
Send word to the jasmines
to bring their tiny whiteness!

I don't want to see it!

The cow of the ancient world
ran her sad tongue
over a muzzle filled with all the blood
ever spilled on sand,
and the bulls of Guisando,
half death and half stone,
bellowed, like two centuries
fed up with treading the earth.
No.
I don't want to see it!

Ignacio climbs the steps
carrying all his death on his shoulders.
He was looking for daybreak,
and daybreak was no more.
He seeks his confident profile

and drowsiness disorients him.
He was looking for his beautiful body
and found his upwelling blood.
Don't ask me to see it!
I don't want to feel the gush
each time with less force,
the gush that lights up
the rows of seats and spills
over the corduroy and leather
of a thirsting crowd.
Who cries to me to come forward?
I don't want to see it!

His eyes didn't shut
when the horns drew near,
but the terrifying mothers
lifted their heads to see.
And through the cattle ranches
rose a breeze of secret chants,
ranchers of pale mist
crying out to the bulls of heaven.

Never was there a prince in Seville
who was his equal,
never a sword like his sword,
or a heart with the truth of his.
His prodigious strength
was like a river of lions,
and his stately reserve
like a torso of marble.
The aura of Andalusian Rome
was a golden mist around his head,
and his smile a spikenard
of wit and intelligence.
What a bullfighter in the ring!
What a countryman in the sierra!

How gentle with the ears of grain!
How tough with the spurs!
How tender with the dew!
How dazzling at the fair!
How tremendous with the final
banderillas of darkness!

But now he sleeps forever.
Now moss and grass
open with practiced fingers
the flower of his skull.
And now his blood appears singing:
singing across salt marshes and meadows,
sliding around frozen horns,
straying without its soul through the mist,
churned under by a thousand hooves,
a long, dark, sad tongue
forming a pool of agony
near the Guadalquivir of the stars.

O white wall of Spain!
O black bull of sorrow!
O hard blood of Ignacio!
O nightingale of his veins!

No.
I don't want to see it!
There's no chalice that can hold it,
no swallows that can drink it,
no frost of light that can cool it,
no song, no hard rain of lilies,
no glass to silver it.
No.
I refuse to see it!!

3. THE LAID-OUT BODY

Stone is a forehead where dreams groan
for lack of curving waters and frozen cypresses.
Stone is a shoulder for carrying away time
with its trees made of tears and ribbons and planets.

I've seen gray rains fleeing toward the sea
lifting tender, riddled arms,
trying to get away from stone
that unknits their limbs but doesn't soak up the blood.

For stone seizes seeds and clouds
and larks' skeletons and wolves of twilight;
but gives off no sound, no glass, no fire,
only bullrings, bullrings, and one last bullring without walls.

Now Ignacio, this quiet man, is laid out on the stone.
It's all over; what's happening? Look at him:
death has painted him in pale sulphurs
and put on him the head of a dark minotaur.

It's all over. Rain falls into his mouth.
Air in a panic escapes from his sunken chest,
and Love, soaked in tears of snow,
warms itself on the summits over the ranches.

What are they saying? Here lies a stenching silence.
We stand before a laid-out body that is fading,
a clear form that once held nightingales,
and see it filling with bottomless holes.

Who's rumpling the shroud? No, it's not true!
Nobody here is to sing, or weep in a corner,
or ring his spurs, or frighten off the snake.
Here I want everyone's eyes to grow round
to see this body that will never rest.

Here I want to see men of hard voice.
Those who break horses and master rivers;
men who, dancing, hear their skeletons and sing
with mouths full of sun and flints.

I want them to be here. Before this stone.
Before this body of broken reins.
I want them to show me a way out
for this captain tied down by death.

I want them to teach me a lament like a river
that has sweet mists and tall banks, that will bear
off the body of Ignacio and let him disappear
without hearing again the double snorting of the bulls.

Disappear into the round bullring of the moon,
who takes the shape, when a young girl, of a motionless, wounded bull;
disappear into the songless night of the fishes
and the white thicket of frozen smoke.

Let his face not be covered by handkerchiefs
so that he may get used to the death he carries.
Go, Ignacio. Forget the hot bellowing.
Sleep, soar, rest: even the sea dies!

4. ABSENT SOUL

The bull doesn't know you, nor the fig tree,
nor the horses, nor the ants of your own house.
The child doesn't know you, nor does the afternoon,
because you have died forever.

The face of the stone doesn't know you,
nor does the black satin in which your body breaks down.
Neither does the silenced memory of you know you
because you have died forever.

Autumn will come bringing sounds of conchs
and grapes of mist, and clustered hills,
but no one will want to look into your eyes
because you have died forever.

Because you have died forever,
like all the dead of the earth,
like all the dead who have been forgotten
on some heap of snuffed-out dogs.

No one knows you. No. But I sing of you.
I sing, for later on, of your profile and your grace.
The noble maturity of your understanding.
Your appetite for death and the taste of its mouth.
The sadness in your valiant gaiety.

There will not be born for a long time, if ever,
an Andalusian like him, so open, so bold in adventure.
I sing of his elegance in words that moan
and I remember a sad breeze in the olive grove.

—Translated from the Spanish by Galway Kinnell

To The Songbird Fallen on the Forest Floor

BRENDA COULTAS

Section I

I walk at midnight on the Grand Concourse of my mind, trying to achieve
the actual location of movie palaces and boulevards. Uphill to the Bronx
to the monuments of Woodlawn: obelisks of the Woolworth's tomb and
Herman Melville's meek grave topped with rocks and coins for luck. The 4
train ends here a long way from Arrowhead, with its view of Mount Greylock.

A map of Manhattan that charts only the springs
To point out where the gray spaces turn to hardwood forests and castles

I never toured Poe's cottage or walked along the aqueduct that brought
water from Croton to the city, where he paced back and forth to High
Bridge; however, I have driven underneath waiting for his thin body to
drop. Am I afraid? I've known ravens less voracious and fatter. A locket
portrait of his baby wife cracks our windshield. The fallen Poe fastens
his coal-lined eyes, fixes a gaze, a bead, to still my heart.

At a forgotten destination
At a damp tomb
I did not climb the wooden and sturdy toothpicks of the staircase.
I did not take from the war chest, ribbons and medals or blueprints for
a torpedo or smart bomb. Nor did I take quilt blocks nor wooden eggs
for darning socks nor board games of checkers or marbles.

Here in this warm space, may obligations fall aside and weep, and my love
poem rebound. I want a lover with tree trunk thighs: A young willow that
bends with
the wind and buds in spring. However, I am cast among the unromantic
who powder and spray nature out of our nature and those who hate the feel
of moss or dirt.

I dress and prepare to walk a hundred blocks uphill along the Hudson,
noting the direction of other people's partners, and the weather and white

froth the river sometimes takes on, and the joggers, bikers, strollers, and New Jersey Palisades, those cliffs of amusement parks that once rivaled Coney Island, that island of rabbits.

Or Rat Island
Blackwell's Island
of plague victims
or city pigeons gathered for warmth on a winter branch

This walk towards boulders of the Northeast, thrusting without sensuality, evading gravity, of pushing the daily upwards, sucking mud through a straw and making bricks. I set my legs to work mixing the muck for a penny a brick.

Pocket keys to a once spanking white tuberculosis ward with a sun porch loaded with ivy and honeysuckle, the kind of place a ghost hunter would haunt. Run my hands along the rails. Fashion a mattress out of old clothes and sleep on a metal bed. Open safes and suitcases from an attic. Find vials of serum. Make a home in the ruins in my best suit. The footprint of an Institute. I might read *The Snake Pit*, or *Suddenly Last Summer*, and listen for Anne Sexton ringing her bell. Wake up and discover that someone or something has taken a bite out of my limbs

About John James Audubon, of said Audubon terrace and Minniesland, take a feather to him.

Walk with purpose and whistle down the avenue
witness where bodies lie close together
from under the celtic cross to a ballroom
homage to fallen bodies of Audubon Avenue

About *Birds of America*: he had a system. The elephant folio is not a folio of elephants, Asian or Indian.

The pages large enough to draw actual size of North America's birds of prey.

The folio lies under thick plastic, and they turn the page every few days
and there is his buckskin suit, his wife's hair combs.

Kentucky and Manhattan wilderness. A highway running along
Audubon park and marshes, too dangerous to trek. Dog packs

John James Audubon, set your slaves free
John James Audubon, study these bones
John James Audubon, pay your debts
Fire up the smokehouse, and warm up the general store
I'll set on scales and weigh myself
Eat crackers from the barrel even as crumbling, stale and mushy
as they might be.

I follow a prayer string from the Battery to the Bronx Zoo, draw myself
up by a thread to the fabled worlds above.

Find Jim Carroll's lost needles and basketball jersey.
Shop the covered charms of La Guardia's market on Arthur Avenue

Section II

I would take my inventory, but I do not own any animals
not a flock of geese or cattle, but a flock of laptops and modems, radios and
cameras, answering machines and televisions

(my ship is a headstone: the ethereal carved into the physical, docked beside
the old Dutch church lately of Wiltwyck, (Dutch for Wild Town).

When living in Wild Town, walking the bluestones of sinful living.
When I am drunk & where there are furnaces
for turning rock into dust
for smelting ore into metal & tool making & powerful hags fly on coarse
broomsticks at night

My name is Brenda Bluestone, I might be Brenda Goodwife or Goodman,
I might be Brenda of the millstream, bookstore or broomstick, Brenda of
the Wallkill, Brenda of the Shaker Villages, Sister to Sister Anne, of the
Mountain house, of shell middens of the Hudson, Brenda of the quarries
and dungeons of Ulster County. Brenda on the bluestone highway studying
the proper hold(t) of stone.

Love Poems from 2001

LEOPOLDINE CORE

for Sadie

Sometimes

like today
for example

it is easier
to write a
love poem
to you

by searching
through old love
poems from
2001

and picking the best one
and making your name the title.

I loved you then anyway.

Hadn't met you
so

it was a weird love
I didn't understand.

It was in everything
I did

Like making pasta
was a way of not
understanding

that I loved you.

Or my recurring interest in god

It was just
a deflated song
of love to you

I mean
what is prayer
but a woman
in 2001

what is prayer
but a love
that isn't there

It was the future
a love like air
faces in a dream

And now there are no words
or
I'm just

less interested.

Language is so broken right?
Always was

lying in pieces.

One thing about a love poem is the line gets longer
it has to

My voice peels back
like a fruit
that dies in the night

Old orange
Not my love

I can't compare this to anything
so I won't

There is a bicycle at the edge of the earth
and a carton of milk

and everything stays perfect-
ly still while I dance
and sing

Maybe the most naked
thing I can do

is make sense
so
I will.

I like the way you look
in any country

Your hair especially.

But everything
I like about you
I like
especially.

Everything glows
right?

Everything with
a light show
in its mouth.

Everything has a mouth
now

Everything is a little bit
holy.

It's easier
now that I'm writing
this

easier
than I thought

to love you
in the moonlight

that is everywhere you are.

It's Hard

LEOPOLDINE CORE

not to hate someone
who hates your mother

even if you also hate your mother

which I sometimes do
for a moment.

But then
to have someone join me there
in the hate

I watch it flee
like a flea.

Who said writing
had to be good

Nobody
but people
I hate.

It's hard
It's so hard
not to hate people
who hate your mother.

Those people
they make your mother

good.
It seems she always was

good.

People think I am kidding all the time.
People I hate.

I'm not kidding
My mother is good.

I knew you didn't really love me
How could you when you said those things

about my mother.
And how could I

How could I be any good
when I said those things
about your mother?

Neither of us were good
in our love that was hate.

It's the kind of thing I can't forget
how much you hated her

my mother.

It's the kind of thing I think about at night in the dark for no other reason than that it hurt.

Not because I
am my mother
I'm not

my mother.

But she isn't bad
my mother

She is good.

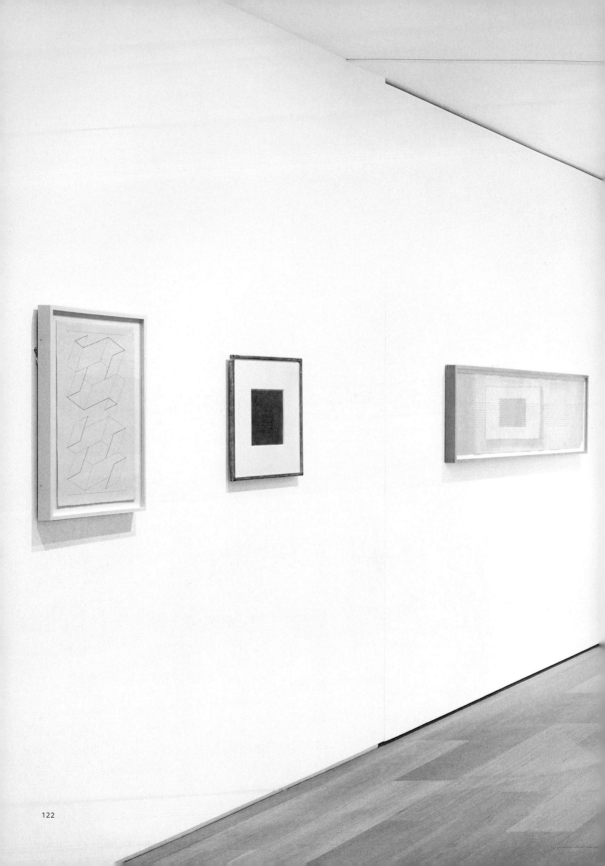

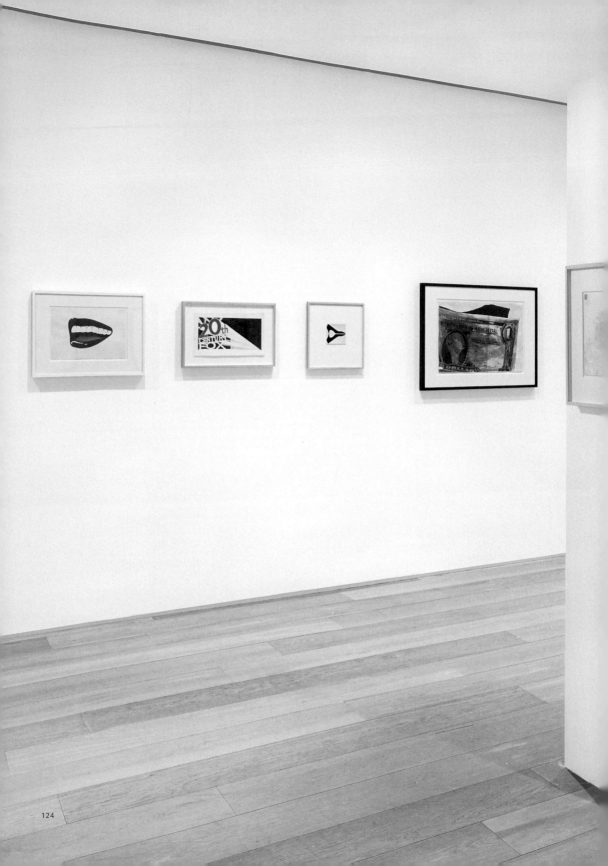

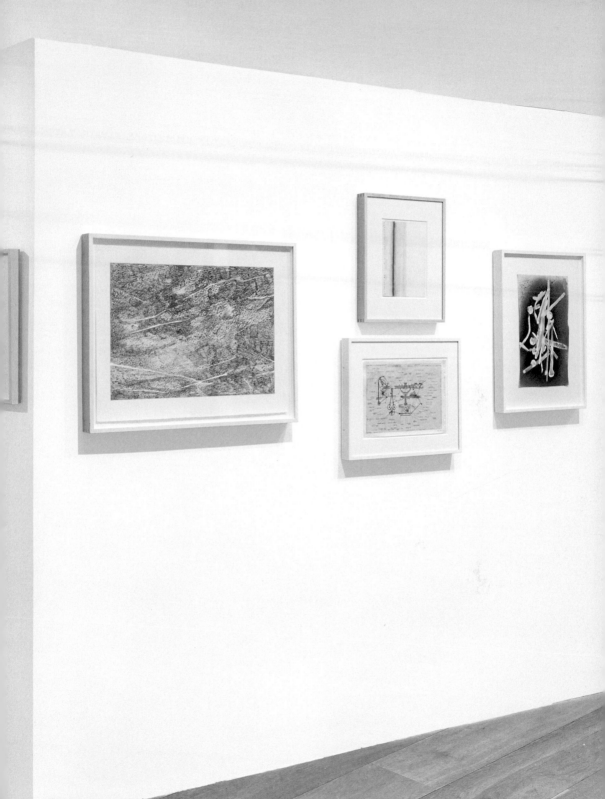

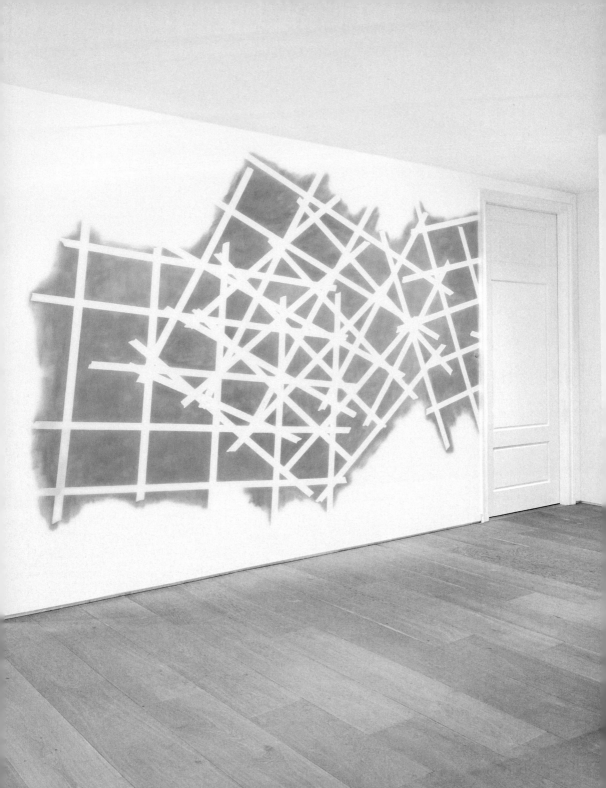

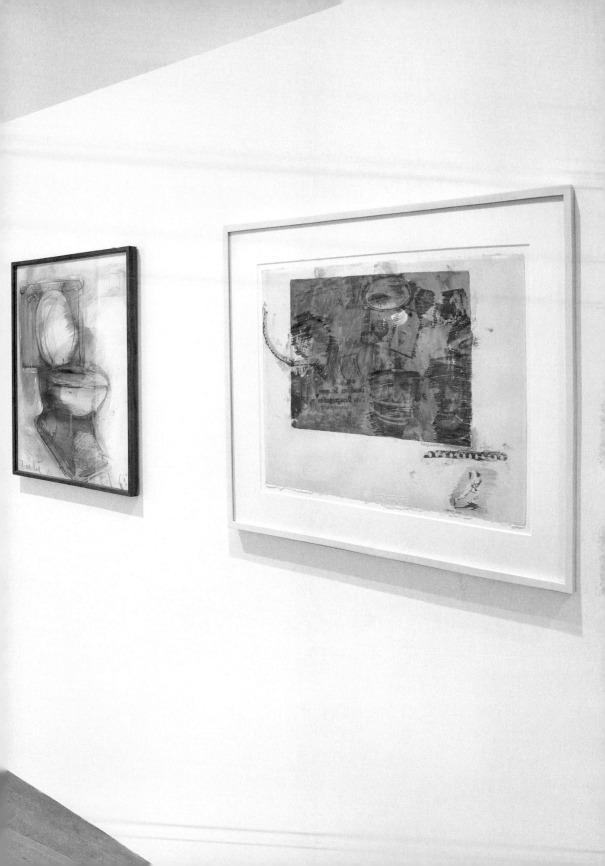

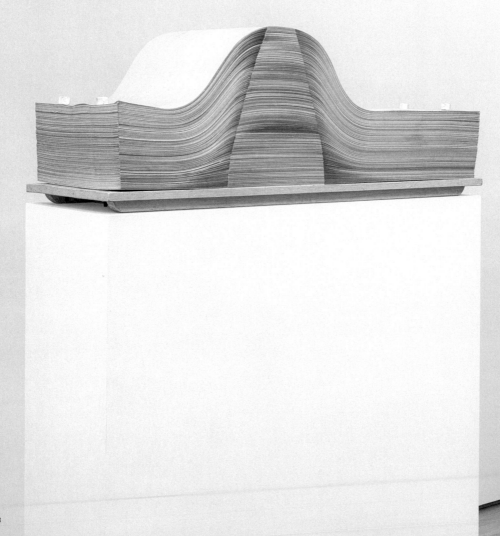

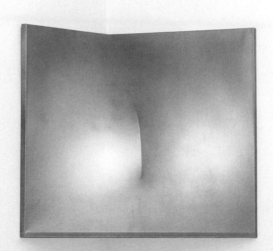

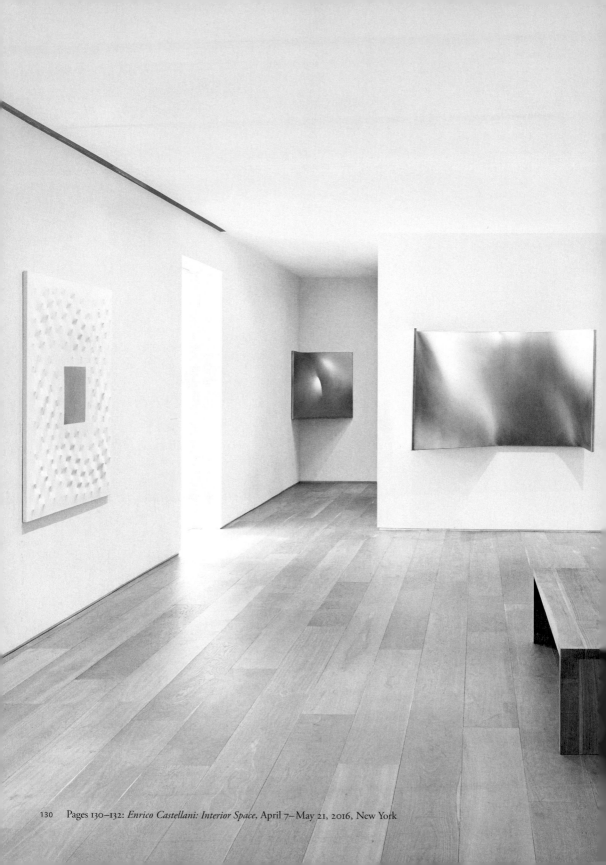

Pages 130–132: *Enrico Castellani: Interior Space*, April 7–May 21, 2016, New York

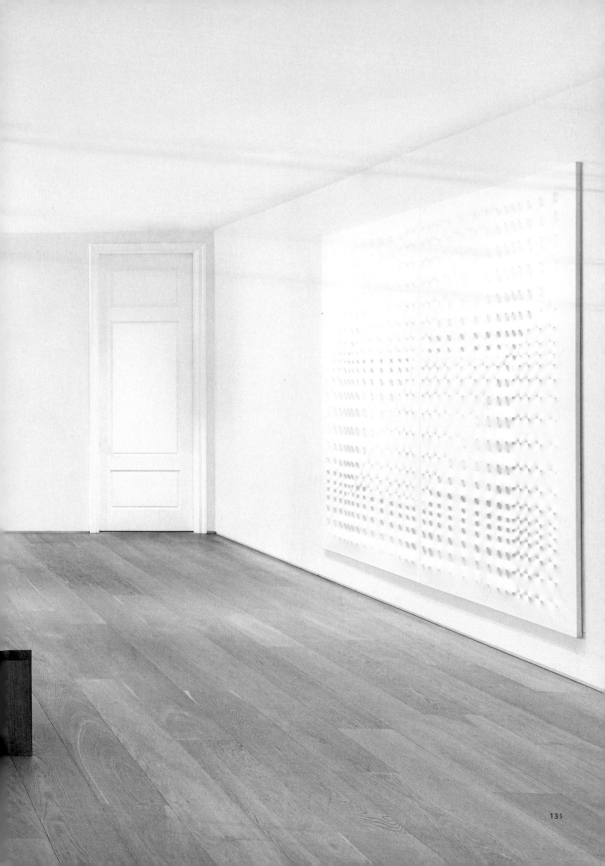

From barbarous abundance: garden full of trees. Two bodies below them oblivious of need, grotesque with fecundness (Elder Bruegel's *Paradijs*), they eat…

You disrespect me; you disrespect us. I am someone who deserves your full attention. He and she have things we don't, and you all act like this is natural??? when they just took it all first. Baby cats are cute; your mother looked nice at the shower. In this fucked up stupid world, can we at least agree on that?

After eating and drinking all day, we had to go. The bathrooms were nothing but latrines—nowhere to do our business. So we left the girls with the beers on their breasts and returned to our hotel rooms to shit.

Is it not enough to be stuck in a body? In a mind? Now a building. Now a chair. Covered in cloths.

It is horrible to be human and cause everything to suffer.
A million bees died today, sacrificed to Zika. Now we are at the end of the world. When I pay close attention, it makes me want to die. (paper closing)

Everybody on the train is special! Everybody on the train is special, singular and full of feeling! How wonderful, preposterous (gratuitous! immodest!) What a ridiculous god (made these)! Whatever.
Off that train!
All of us in awe of the air above ground and the trees—giant, really just sooo big and green like you've never seen it—*Lush* (It's a park). Then we all go someplace different and eat dinner.

Garden at Night

MARY REILLY

The lake, all lightly lapping, halts.
The last geese (who should never, in winter, have stopped
here anyway) flap away in VVVs.
Bad omens, the people ignore,
too busy on their phones.

And yet, they do come down to skate,
so proving once, for all, *we still own skates,*
like weather, flush in cold air.

At the edge, they josh,
sighing, all of them, secretly, it's come again, see: Winter.
Winter when they said it wouldn't,
and after winter certainly spring…

~~sky from water. land.~~
~~our earth wild again. Vines. Fruit. Failure.~~
~~Little coats made of skin,~~
~~Protect us. (weeping God), final exit~~
~~to desert wind, barren rock, behemoths, swarms,~~
~~hard labor, ourselves.~~

~~Had we remembered it would all end, what might we have said instead?~~
~~To you dead so soon, how might I have said it.~~

~~just before you sleep (two beats) a moment's peace.~~

The sun shines for you, he said when the sun was shining.

To utter such nonsense in daylight…What a fool!
Forbidding one thing, he promised another.
Knowing full well we would fail, he gave us everything.
Twice.

Nighttime now, all he left us is ash,
a shock of corn cometh in in a drought,
hacked apart for kindling.

Alive again, what might he say, out of the whirlwind?
Something useless, surely.

[Twins and immaculate inseminated]

BRUNO CORÀ

Twins and immaculate inseminated
reliefs of these enchanted fields
Enriculturist of Light.

Irradiated arcade clouds
rows of contrasting flexions
heights, graduated measures
of how much the seed provokes:

Doesn't the whole of time
lie within Day and Night?
Doesn't the exact equation of the living
quickly move on the Breath crest
from the breast to the navel?

Papers, consecrated hosts of art
supreme lay nourishment
mutant waves of dunes
gothic silenic horizon
 Epidaurus in the Arctic!
whiteness in the midst of shadowing antinomies.

Smiling hills valleys
of the coin Moon, such places

more or less the same.

—Translated from the Italian by Howard Rodger MacLean

Trous

EMILIO VILLA

titolo
titre
autout
douté

le grand Jeu
du
Trout

le petit Je
du
Tout

mais une boucle
sans trou
sans) jour dire
sans jeu
qu'est-ce q'que pourrait-elle

Holes

EMILIO VILLA

titolo

title

of the doubtful

whole

the great Game

of the

(W)hole

the little I

of the

Whole

———————————————

but a mouth

without a hole

without day

without games

what could it say

—Translated from the French by Sylvia Gorelick

from Spells for Solids

KAREN WEISER

Grows larger, sudden blur as it becomes alive
gets a name when its outlines are traced
although one that is perpetually interrupted
says, on my shoulder still, that you existed before The
interrupts your present self. Night leaks out.
Move. This point, the cotton layer of silence
of narrative possibilities you have entered
(the halls of the dead) is to wonder what
and so I concluded in my fitful way that the
passage of time it takes for these words to reach
the workings of thought; but the more I deliberated
on the process of a thought, the more the water moved
over the edge to where I stood. It is perverse to record
vision, only to shift out of range when to focus
something is squeezed out.

As I, and her, it loses its boundaries, which
margins of pure light as my eyes refocus. Then nettle, to the
good feel. You are. Love-balloon caught in the tree.
Cast no shadow but the conversation has stopped in
strangers. Turn you to a page without looking.
The ocean or even the rain can dislodge the
them, ignoring their slight shadow, but
glimpse, and can't, these obstructions
in my eyes. Sitting in
the lag of
time.

She examines its structure and sees, as she peers
that each room contains a mirror with ghostlike
eyes, awkward sloping stance that makes her think
its seams, from the other side, though that
retracts me by the nose, with its evanescent smell,
and all The to the night go dim, leaving us alone.
Know every dollar I touched was dirty because
Waking, I do not know that she has died.
Open my front door. There in The is the solution to
wax the rain will make visible, fleetingly,
enough to imprint a dark spot? Many workmen come to.

looked at, reflected fractal-like at a myriad of angles,
 Some gold, brown, moss green, cloud. I can see
illustrating systems, the pens in his shirt pocket that
he sang a prayer to protect me. The day's seconds are
 spaceship's walls, and the alarm sounds as
parts of you, the majority of you perhaps, do not.
The field of vision a wax coating, as if the humid
are threading one moment to the next with the large
rather of your body. My ways of looking have my gaze
 floating peripherally, a guarantee against itself.

It will be
a surprise rain will make me feel.
You will not dream of her at some point
when the fragments of you reconstitute in

the future, when parts of you agree that she has died,
themselves into a new broken shape, a movement.

In the painting, he is eight; on his left his mother sits.

Her eyes are dark and large, holding fast

anyone who looks at her, the stubborn of
faded blue, her hands left a blur,
her mouth, The,
ungraspable.

2.
G r
ows la
rger, sud-
den blur as it
becomes alive gets
a name when its out-
lines are traced.Although o-
ne that is perpetually inter-
rupted. says, on my shoulder still
that you existed before The interrupts
your present self. Night leaks out. Move,
This point. the cotton layer of silence of
narrative possibilities you have entered (the
halls of the dead) is to wonder what and so I
concluded in my fitful way that the passage of ti-
me it takes for these words to record the workings
of thought. the more the water moved over the edge to
where I stood. It is perverse to record vision only toshift
out of range when to focus something is squeezed out.

Bill & Ted's Excellent Adventure

EDMUND BERRIGAN

When it sank it thundered

Wonderful cries luggage

The dancing bustle of water

Exaggerate shoulder

Nothing for all your trouble but a bruised

Everything takes place

"Good old desk" he said

Deliver us from swivels

Lean outward, I can remember more

beyond this and that

Bands of distracted emotions snap

Your words will be guides

Is your beauty parlor

inquiring after you

You would die first, wouldn't you

Take off your games of chance

leading with his chin

The earth opens and swallows you

And the lights go out all over

the Flatiron building

which brings me to the part

[Died in a back bone]

EDMUND BERRIGAN

Died in a back bone, little scraps scarred
the world is open to us on the top deck
who no longer require this information
Dear Dad, the circumstance of dreaming
holds us together, while the express pounds
the nearby tunnel, hanging glib remarks
about self-censorship. I was thinking
also about the great escapism, and our
long hours of public service.

Quipment

EDMUND BERRIGAN

Hanging plants in the window
Ghost graffiti on the machinery
 near Nostrand and New York aves

He says the only perch is
 wherever he lurches to

The greek refs were mostly dried ink
in the poems after his
self-censorship

 and when he came to
the future the immediate present
presided over epoch
 concerns

There was nowhere else to go
 reciting in prison
 to the withered gray matter

Struggle

EDMUND BERRIGAN

The kind of poet who gets mad at the present
not necessarily New York, like walking the streets.
For personal crisis I'll read anything, anything
I can think somewhere else. Where would you be?
An emergency, I have an appointment.
But measuring one's own necessity is midnight.
Figure out if someone needs to go the hospital.
Then? Theory is useless when you're trying
Weirdness is what I prefer in poetry, Denby
For locating them. If only time would go
I work for my vocabulary, not the other way around,
said Memphis Minnie to Emily Dickinson,
and here I am at the Lennox Hill Hospital.

[I'm not a guy who]

EDMUND BERRIGAN

I'm not a guy who
equal saturation
peoples that job
middle-class pains
a significant source
of temper tantrums
in a rain check

I'm a guy who
mangled hands
in the earth
I broke through
the ethereal

California zephyr
invisible necktie
in the private property
lost in the paprika
of checkered skin
of magma jumped
Mr. Belvedere dying

electric eels
I loathe & seethe
optimistic mayhem
beautiful conscience
neatness of

drowned optimism
a red real flag
so sad your
Benjamin Spock
bees off planet
off bridges
in a fisherman's hat

reaches out to
lock on thinking
of bacon and broke
misunderstanding
kindness

Path

YUKO OTOMO

I stand in an open field

To *see* a voiceless voice
And *hear* a colorless color

I have neither form nor purpose

I breathe in the textural nuances
Of parched, denied, scraped and resurrected fragments
Of the history I was born into

My memories have no walls, no ceilings, no shadows or shades
I cannot trace their reflections even in the most forgiving intimate dreams

The density of a language I faintly recognize
Has no comma, no period, but an occasional involuntary ellipsis

The air I throw myself in has no doors, no locks, no keys or secrets

How can I remain true to my *raison d'être*
In such an unfathomable landscape of being?

How do I go on?

In profound despair
In the stillness of time's flow

I learn to become one with a humble and austere meditation on my path
As I yearn to listen to the quivering hue of remote morning thunder

Similar to the one I heard when I was just born

—Commissioned for the exhibition catalogue Chung Sang-Hwa, *2016*

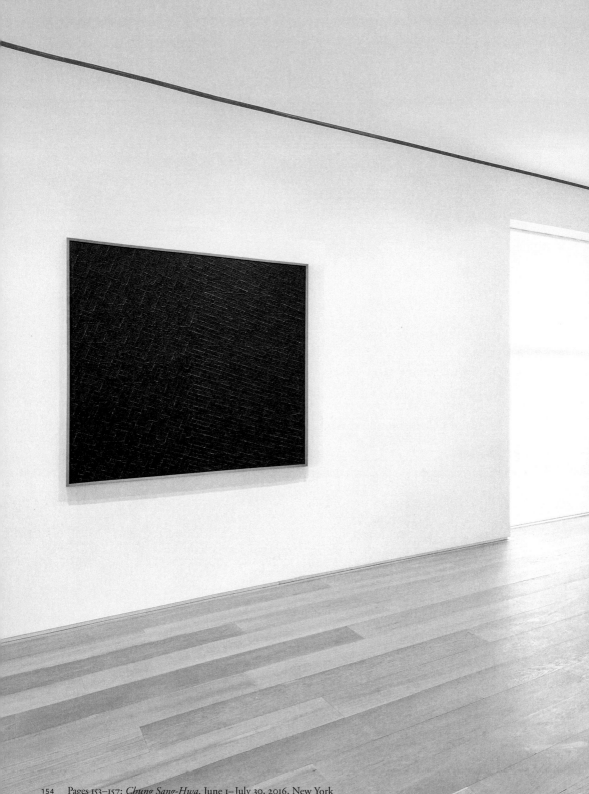

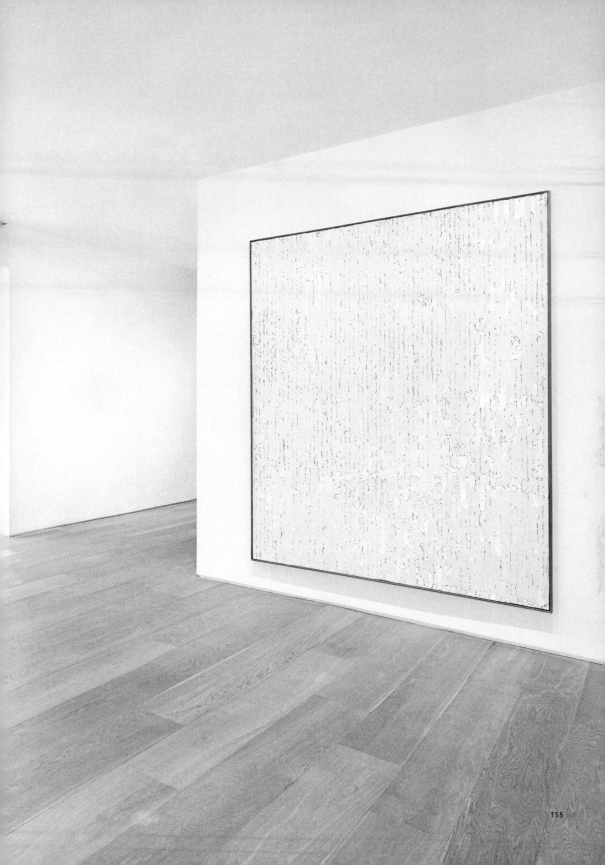

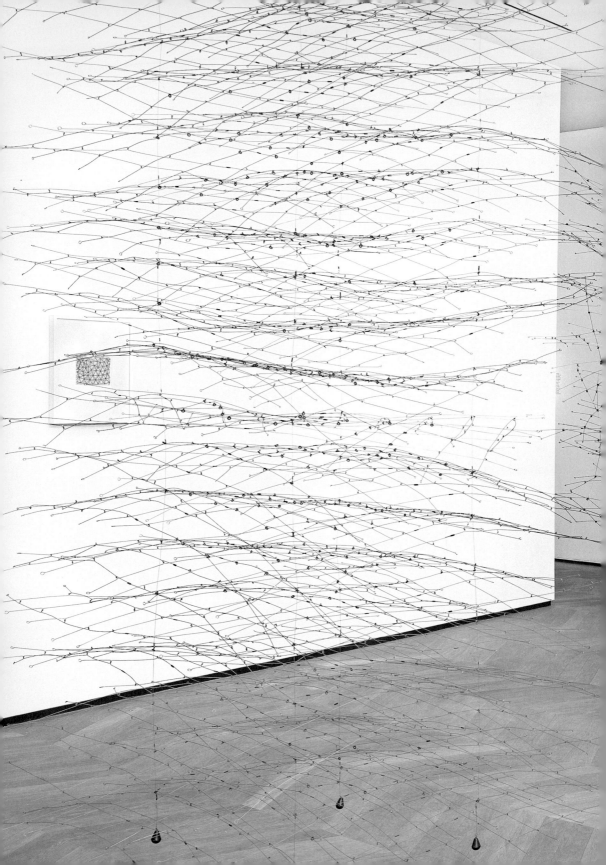

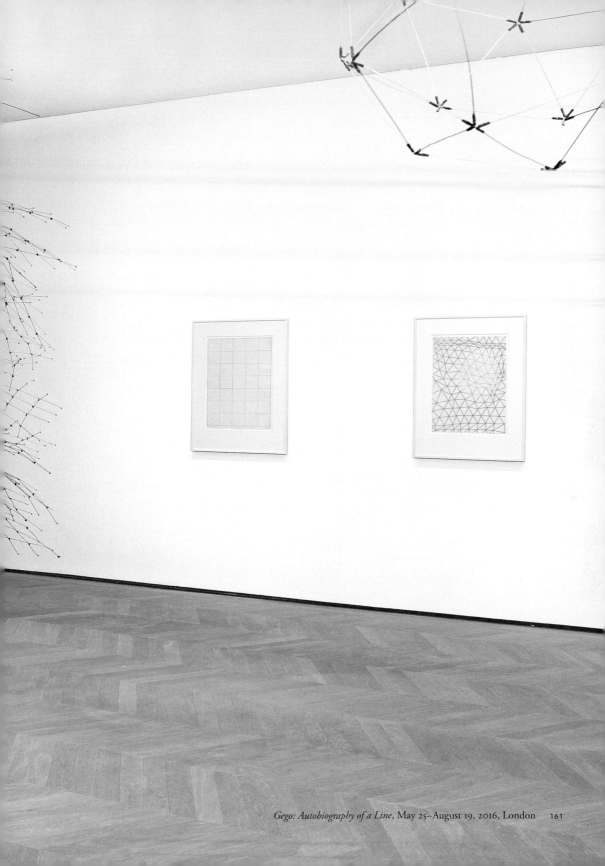

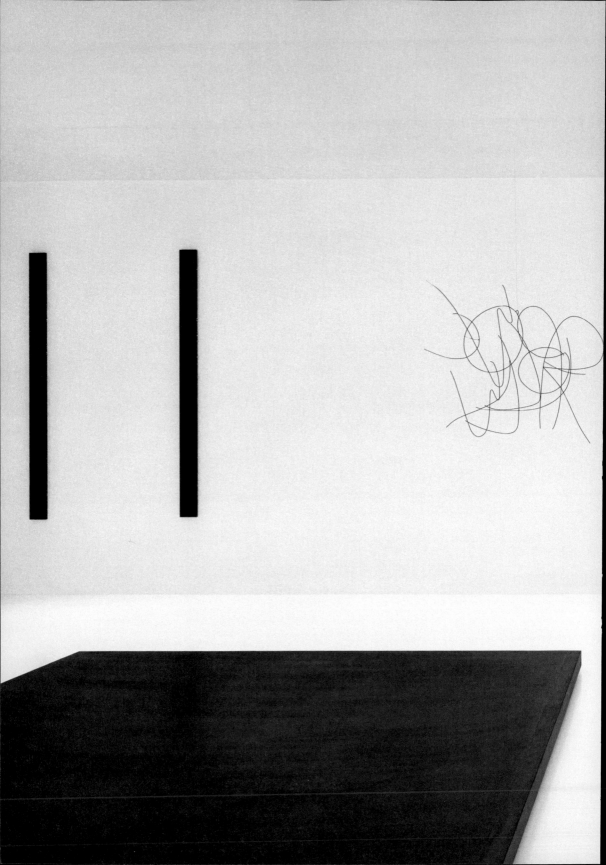

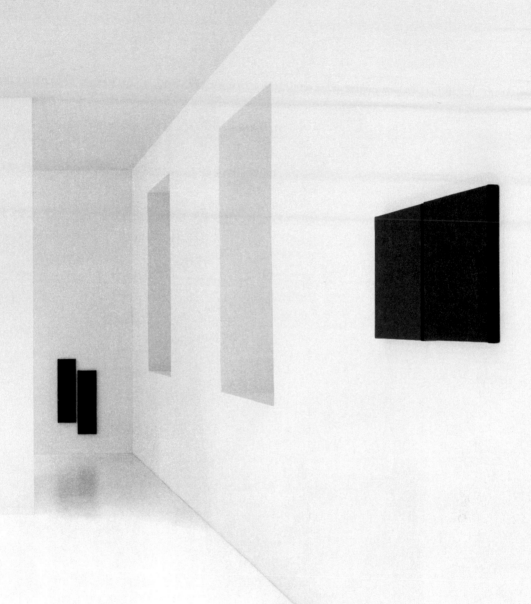

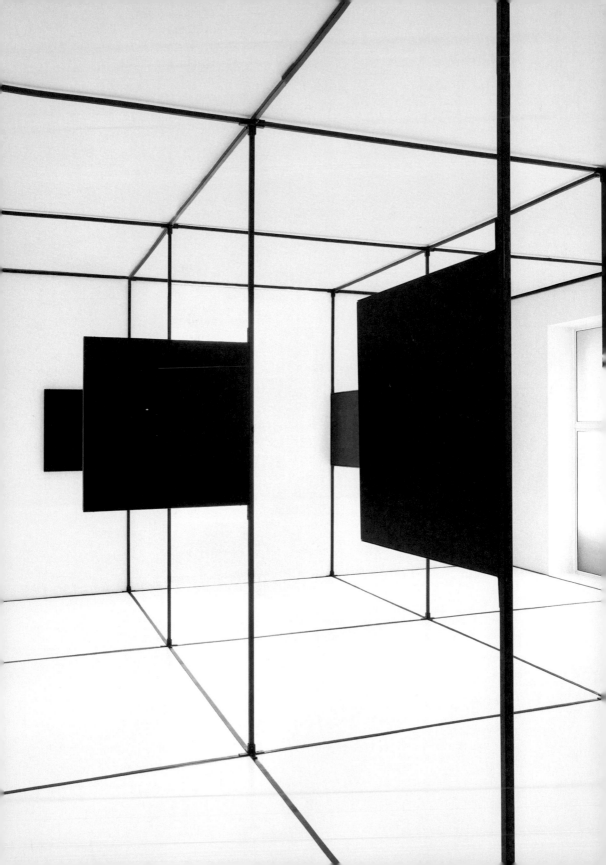

A Performance Architecture: A response to *Situational Diagram* by Karin Schneider

ERICA HUNT

Preparation for this performance began with visiting Dominique Lévy Gallery on one of the days Karin Schneider and her assistants installed Situational Diagram *and engaging in relaxed, informal conversations with Sylvia Gorelick, poetry curator, and curator/theorist Begum Yasar, as well as Karin herself. I returned for a second visit, attending the first poetry readings given by Brenda Coultas and Amy King. I noted that blue square fields float on the black painted surfaces that divide and organize the second-floor gallery. I also noted that the backside of each painting enacts enclosure, intentionally left blank.*

On my third visit, I sat in the gallery nearly alone, though there was always someone, the guard or another gallery employee, a visitor, or the photographer who was documenting the exhibition, with me. I listened to music by Fela Kuti on the walk there, and Arvo Pärt on head-phones in the gallery. The music had its intended effect—to create solitude, a personal stillness.

The tripartite division of the installation suggested a three-part performance/poetic text organized around three words: Mirror, Mask, Missing. *These three words came in response to the Black color of the paintings, connected to recent reading and writing about Black ontology or Black-being-in-the-world (George Yancy, Fred Moten, Franz Fanon), and the recent visibility given to extrajudicial killings of Black women, men, and trans people, a measure of the limited curve of public tolerance for Black being (or performance), addressed by the Movement for Black Lives.*

"These connections operate like a fulcrum, a hinge point able to pivot in almost any direction where any method of composition may be explored."[1]

As a final note, the poems "Suspicious Activity" and "Broken English" are from Veronica Suite, a Lamentation *which deals directly with the poetics of Black grief.*

As a means of placing the performance, this new text and me in the room as fully as possible, I began with a song.

Mirror

Who do you see when
you see
you?
Who sees when I see
me?
It was very hot that
summer with
temperatures so high it
drew remarks. And I was
compelled to carry my
own defects around,
exposed—Happily,
luggage has wheels to pull
around grit and
disappointment, as long as
one stays on the right side
of realism—to avoid
being crushed.

I open my eyes
wide (I'm not just a
passerby) to see how long
I can hold
trouble at a distance
give a gaze as good as it gets
ripeness to the pronoun's
gloss on me.

The mirror reproduces me
anagrammatically
mire rime moor
room rim rerim
mire

Mask

The mask marks the spot,
focus.

The back of the hand is
not the target
of the picture is not
the portrait the picture
was meant to replace:
this face was chosen to be
invisible; to be
invincible.

The portrait

Behind her still face
waters rush headlong—
light easily
concealed behind her
resting face.

Still questions cave in.
choose sides, meter the
dash and famished; she
fills in for false promises.

Behind her still face
is more than the machinery
for seeing safely,

Missing

I follow the flock of
tourists flooding Astor
Place and its missing cube.
Pose there, the image of
flesh wound, harmless,
tongue cut, Black, standing
out in a city I was born
in, smoothed out.

The photo's make-believe
is hardly discernible.
Sound removed from the
picture you can still make
out the breaking point.
See the arrow?

Missing

I pick up at the breaking
point. The air is thick, hot,
a street cleaning machine
menaces the curbs,
panting out clouds of
debris.

I find lines under my feet
and a shadow on the floor
I don't remember
collapsing, and it stops me
in my tracks.

Mirrors facing each other
multiply storm of lost
edges blurring
around me
unsteady picture.

Abandoned mirror—or
image starved of its
reflection
shrinks inside dream
dream spills tune
tune surrenders holler
holler loses its voice
voice loses its numerous
way melody bounces
around a choir
way a choir harmonizes
through
a thicket of moans

Mirror where
forgetfulness is forgotten.

A mirror where someone
makes stuff up; the self
that competes with a
projection suffocates in
the im-
possible to forget.

Possible to forget
the person standing in
front of the mirror
stream breaks the person
into pieces

Behind her still face
a bird's eye
spots turbulence, joy in
the brass
anticipates grace on the
tongue.

I am not you but some
other
other, even to myself.

She is never at home.
She is a visitor.
She visits two or three
aspects of herself
visitors are permitted to
see.[2]

She has gained permission
to visit herself. Look
carefully at the back of the
picture. The back of the
picture is not there.

She is the blind spot in
the eye of the beholder.

visibly black and yet
undetectable
to the white world's eye as
blank
undetectable autonomous
zone of being
subject matters. Black
subject matters.

Parts of me grow thin:
pale tattoo at the wrists
marks the unnerving
where they almost wore
out.

I am lava lamp snow globe
push button automatic
paraphrase tactical and
syncopated.

I pantomime all logistics
all the time.

It gets me from place to
place, yet I check my
heroic proclivities: call it
the long view.

I know there is a limit to
easy.

Luster comes to haunt me:
"heard a cry in the
mirror"[3]

Person breaking into
pieces.

I look in the mirror and
see me on the blackboard
as black as red black
as can be.

Mirror of breaking
water, unstill, restless.

I stare into my Black
mirror
my back to the mirror.

Gaze into a Black mirror
As into a fold where
"walks in beauty, like the
night
of cloudless climes and
starry skies"
where blackness lightning
electrifies
where silhouettes
collide and pinwheel
blue, black,
speaks,
volumes.

The first mask:
For a while I was the eyes
for she who could not see
yet was in charge of
protecting me. I was her
watch and my own. The
keeper of the portrait. To
reflect her. I was
rewarded for my vigilance
with the power of words'
illumination and
theoretical thickness to
the said.

Three-dimensional body
in n-dimensional space,
together we moved
forward and back in time,
walking what can never be
explained through wind
and water.

I was named guardian of
sunlight, the designated
observer. What gave me
the courage to witness? I
edited shadow. I played
the role of reason under
the stern gaze of ***the
worst news ever***. I
continued speaking to
shield her eyes from what
they could not see?

Suspicious Activity
—for the missing

"43 percent of the people
killed were not
committing a crime but
were stopped for
suspicious activity."

A resting face.
She abandoned the cloud
and chose to go out on
foot.
She was missing a grin.
She knocked on the piano.
He defeated a match stick.
He crossed diagonals.

They moved past an
uncovered spot.
They lost pump.

He was bowing in erratic
directions.
She ran by spurious gloat.

They were potential
troublemakers who did
not fit
the turn-down dressing of
the neighbor
hood who was speaking
in concealed carry.

Lockdown

How could I trust the
street signs, yet there was
no choice but to cross at
the crumbling
intersections, sense of
direction lost.

To accept echo where the
original sound was
inaudible, or hearing no
echo, no irony or pattern
at all, to take in militarized
clamor at face value, the
providential occurrence of
running into someone
back from the dead under
a rock.

Mask

She kisses Cannibal and
marries Caliban
And devours the flesh of
the beholder.
How she has gotten under
his skin!
Her well known musk and
enormous feet
The explosion that
detonates in her walk.

He bolted out cork dizzy
thinking free from the
lockdown.

She traced the body.
They refused to fit a
grammar of
disappearances.

She studied how Black
people get excited in a
manner different
than others drives
some people to
blunt displays of panic
and violence.

Lamenting in an
appropriate structure has
rendered her hoarse from
not screaming.

She is blind from reading
from inside her lids.

I would show you where it
happened on a map, but
the cursor of the public's
attention has vanished.

1. From *Notes for a Performance Architecture*, which starts out as a meditation on the Cartesian grid—to illustrate modernist poet Louis Zukofsky's assertion that poetry is the negotiation of tensions between "upper limit music" and "lower limit speech." The essay moves to explore the limits of the grid "with its prescriptions and presumptions of up/down, left/right and the connotative baggage of hierarchy."
2. Yusef Komunyakaa, "Facing It" in *Pleasure Dome: New and Selected Poems*.
3. Clark Coolidge, "Arcane Hemispheres" in *88 Sonnets*.

Broken English

ERICA HUNT

Wound up in words

wounded

re-wounded

the beaten

bulleted body

repeats

wound

reads

into ache

stead

or not

ready

red

or not

b/red

read

b/roken

syllabl

es de

tachm

ent. It's

no better

It ren

ders

s

peechle

ss

tend

ernes

it

strip

s

kin

died

lik

e

ki

ndling

i/nto

bro

ken states

rende

ring

ileg

ible

and unintel

igible

wher

e

blac

kness laws

severed

tongu

to co

wer

us, and s/cowl

us de

ad

mute.

Yet she (I)

to speak

all at once

the thing

that has been on

her (my)

mind

which words

(verbs)

reco

ver

dignity?

Restores

letters to the unm

uffled

(unmuzzl(ed))

full-

throated sound as if

some-

bodied?

The dead

lines (t)each

the proper order of time

scorch (ed)

zones of property,

propriety's

(in) tension

returns me

days after day

to variations of question:

how to breathe

freely

despite shackle-rattle and

pummeled jolts?

In words we do, act. resist.

(from *Veronica Suite*)

—*Commissioned for a performance in the exhibition* Karin Schneider: Situational Diagram, *2016*

Ode to the Artist in His Natural Habitat

AMY KING

Poet is too limited. *Supreme master* better conveys
the level at which the subject functions as agent, footsteps entitled
through halls and rooms of the men that come and go, talking of Michelangelo
and self-made destinies in an ocean of lesser sirens, lesser crabs, lesser thans.
That is to say, a promise was made for 15 minutes, the gamble of which
violates for actualization at cost.

One could say the subject–agent default is white cis-male of hetero-plasmic
technological prowess. I too have admired this view, the slink of smoke insidious
through a city and industrial strengths measured as the wealth of nations.
The rest are basic bitches, not we, the cis white males of Wall Street and health.

Dad g$ves to museums, foundations, curators and New York literati.
These gestures deliver son the papers to access and microphones.
He makes nothing. He is failed on purpose, testing the teleological dream of America.
He boasts his disdain for side-by-side living. Your body your mind your life
are his material. Shell-shocked or shell-bound, you are siren or crab, you are lesser than.

Is there a union of infidelities to explore to mask to magic our way in?

Cultivate awareness of how all factors influence and impact how one navigates.

Employ a variety of tools to interrogate conditions and how they are farmed, defined,
exploited and mimed. Call out the man who steals your moves for his own mask

One is to ask, "What would be different—Is this agent a Y2 other?"

But. He thinks freedom is theft, infringing others' spatial-depth dimensions, taking their
liberties as barter for existence, promising returns on the division of labor where his is none.

Because he thinks freedom includes shitting on anyone, even to prove they belong
to him. Break apparent.

Privilege, he performs, is a courtesy, an "It's nice to make your acquaintance" because
the access and mobility each agent provides is a handshake of like interests.

And he stomps whomever wants respect because history says they deserve otherwise,
the mysteries of capitalism at work at play.

He thinks *American bootstraps* is his right-of-way and inheritance of ironic metaphor.

Supreme marketer better conveys
the level at which the subject functions.
Shift to the irregularities of generative angles.

I am made of doors, enter to depart, and poetry has ruined my life
as prescribed, if only to become something ineffable, non-categorized.

Entryways littered with cigarette butts
ashes of victims,
bees trapped by hinges, the movements
in minor keys, literally.

No cumulative moment of patriarchal excision presents. Slowly, slowly, wrenching
shifts to discomfort.

Returns to the dominant lens by necessity of violence for survival.

Tries various paths with toes dangling in water.

Knows some women don't adhere and therefore shifts to outside the male code, which abhors
the suggestion of an inner appropriation, the notion of womb-like comfort. Metaphor needs
new shoes.

Witch trials, vagina dentata, Medusa, snake and desire.

As his is survival with ease: alpha, male, control, demand, go-getter, by abuse, calculating,
trail of victims testifies with adherence and to loathing.

Find your inner culture. Take what never was—yours.

Sitting on deck,
small rains
Canada Day–adjacent,
bookends
Independence Day.

White woman,
tennis smile,
the never-straight ride.

Your arms raise in the shape of goodbye.
A car ride feels like a slap.
A TV show's commercial line-up
break is the length of several generations.
Progress is a circling fly found only on a map.

I am this shadow with no bones sitting here slouched.

Working for the NSA was not like life. Here's how it was in affinity:
a heady, boring mix of misery and mystery, the sadness of power,
the most boring thriller connecting satellite channels to super computers
and the length of process has been a shifting death star.

Cog of nothing, cog of replaceability. The in-common of the common people in relief.

Time is still a dare and its color dies in my mouth with each input, each expression
of completion.

I suck on ancient cave greens in sequestered cubicles of clinic defense and sanitized government, as in:

The primordial is why I never let them take my wisdom teeth.

How does power adapt: male or female connector?

You cannot answer for all because the audience interprets in context.

You cannot sit in fire and expect the capacity of physics to keep out.

You cannot say things and expect the mouths you speak not to be present.

Things aren't getting worse, they're getting seen. How hard is this.

Things aren't progress, they're shifts and transformations.

Assassinate what you don't know, gulp the fear of every kill, conflating voice and culture with a justice system you think believes you.

Performing anger is not synonymous with violence; performing voice is not the same as speaking. Is not the same as being heard.

Elsewhere down the road, keep the clover low, the fern forest tame, see the life in others so you can see your own.

An overlap in outlines is not the same as a shadow engulfing. Is not the same as gulping.

Nature is control, for some, a misnomer.

The soft singeing, not quite a hum, in my ears
helps me see highlights between the rabbits here
on the mountain fucking, unthinking about the hawk hunting
a mile up, the thin orange streaks between pines
between the hares' hairs, electric charity,
a calm scene with hints of charges in concentration,
concentrated, lives expiring while living:
a charging coyote, a clogging artery,
a truck at 45 speed or a Manhattan curb across bodies—how much of death is sameness?
The singeing a compliment to the blue green olive palette supporting
soothing our love lights,
our love letters as simple as the written word of each breath taking in, sending out as reflex.

Why we stare into the fire is one of those things too:
People are attracted to the object of theft,
forgetting the raft that wrenched and took it.
The destiny and density of desire's fire, a bloodlust,
an oxygen lifting limbs and steps, ambulation motored by the unclaimed-to-date.
Animated, energized, because we are none but ourselves
And that may be boring, but ours.

Back to the artist: where people are fighting to be heard,
to not be murdered, he aligns himself with power as triumph, trumps
the lowest expectation to illustrate just how low to flex
because power means not just the highs but especially the lows
to enact his own phoenix-myth recovery.
He projects an irritating film on poetry's windows
to highlight his smears, his breath on a portal,
claiming he alone is affecting the view.

He cites histories of his kind, historical traces, because power of this shade
is always proving its relevance.

We take these truths to be
formalized exchanges
premised on original backdoor deals,
the coming together,
taking differences to dominate
a common other, an enemy he pushes with words to dissolve into static.
The performance of a body as theft and erasure to render the artist imperialist.
Ode to the artist of precedented scripts on the path of least significance.[1]

1. For a good portion of this piece, I kept in mind the failed sculptor-turned-"poet" Kenneth Goldsmith,
who "performed the autopsy of Michael Brown's body" on a stage at Brown University in 2015.

from If I am Teachable

SARA JANE STONER

after Karin Schneider

Through the open cells a tour a march

 I pass white timed to model

 some known outgrown emulation

NO

 steady horse no pull in kick instead

descent to the killing place

 death place of the thing that would

body with the body of a book

 on its head still

I step to to make outside imprimatur

 prime the ass to tongue to teeth

 to finger

this astronomical pile I agree

 walking through

blood luxury pedigree chemical smoothing

 I agree

with myself to arrive at death

with my actual face eyes blazing

*

In the ocean some child I sit

 past wonder battling for upright

in the battery

letting the whole of it make something of an

 absence totally shared can you

sit with it

 As if the apparatus of your thought

cellular discursive shove and caress

 could be encountered with a breath

inside of knowing all of the things

 touching all of the things touching

you in this moment

 This room makes a slap

 system paused

so you can dare yourself

 to appraise your (desire for) color

 *

They do not swing but swing in angles

 unhinged hinging

motion out those curves like nearly silence

 faces peeling past

like aggregates of shot of bleed

 of complex strokings

as the line you queue up enters you

 bodies falling

now passing through the open cells

 not needing wanting

faces wanting not

 but needing faces

 *

I cannot brook the mention of that oil and coal

 without the sensor of my tongue

I cannot

your pointy shine theory imperial soft

 armor money money

make a mirror of the world for you you make you toward

the effervescent iterative prosthesis

 bonds the decorative id with capital

well-named parasite assemblage spirited away

rehollows out the lack

 all the self you self to make it

make it justified

 we practice so much blood sacrifice

in the windows of what we pretend not to

 not to want

the song your cells are taught to dream of

 closure

that white room you make do in

I put on the ocean

 and flip through your face

 oh stubborn transparency

 of projection's need for power

 your beautiful face watch it peak

 watch it hide in itself

 watch it rearrange against your hair

you put on your eyes

 and I welter you finger through

 my welter

 with your eyes

I am faceted of for your many vectors

I am faceted of for you

I turn off the ocean and

 now my eyes tumble

 down its echo

 every word you use says something

has something to say about your I

what you

what do you do with the liquid darklight

 aflow between us

 *

Those proportions

 I am associate of that indictment

with my own rupture conditioning

by the parallel staggered heights

 hollowed again by the nuclear glow

of that national name

 that taught

If I am teachable by those shades of black

 hung on the wall against the white

 the neutral nefarious

of the blast function of contrast

 the artful produce surface light and depth

Oh the matter pertains to its

 pertinence But

 did you read it

Who has the time I always ask impertinent

Who has the time

 to read it

Who has the time

to feel at the sutures of monetized light

unwind of what good citizen scholar

Is the primer composed gathered granted

 for all the scales of word of doing of event

 of violence in your life work

on the wall in the text in the bed

to open you

 to your fleshly irregular

your substances aleak your

labor

 a spill your prone and boxed flay to systems

you want to place outside like a bad dog

 the size of the world

you feed on the starvation

 of your thought

 *

Everyday I pass through the open cells

knowing not not what is caught

 what is free to feel framed

momentarily can you see the faces

 for whom

obstructions multiply

 as they appear within you

 (a) systematic application to

I see it I see you I see it again I see you again

 I see you again and again

I prime the lurch to see you

 again

Rustle tick saturate blood running in air

 too many surfaces to wash

with that lunar pulse but she does it past

 what rational golden mean

 our absconded ever

in the yacht on the open sea

in the blood spilled on the street

in the pockets of darkest soil in Tennessee

 as if richness were a metonym for

murder

the travel of meaning elsewhere

 as if

parle(s/nt) *parlons* *parlez*

 your sonic push could

tilt some mind can

tilt some mind will

tilt some mind

 a dip of rim in you a dawn of over into

the whatness of ever into unto athwart the X

ever essaying ever assaying

 but and more of more patterns makes somebody's

brokening abstract machine

 your age in motion

 so all your matters mean

—Excerpted from a performance commissioned for the exhibition Karin Schneider: Situational Diagram, *2016*

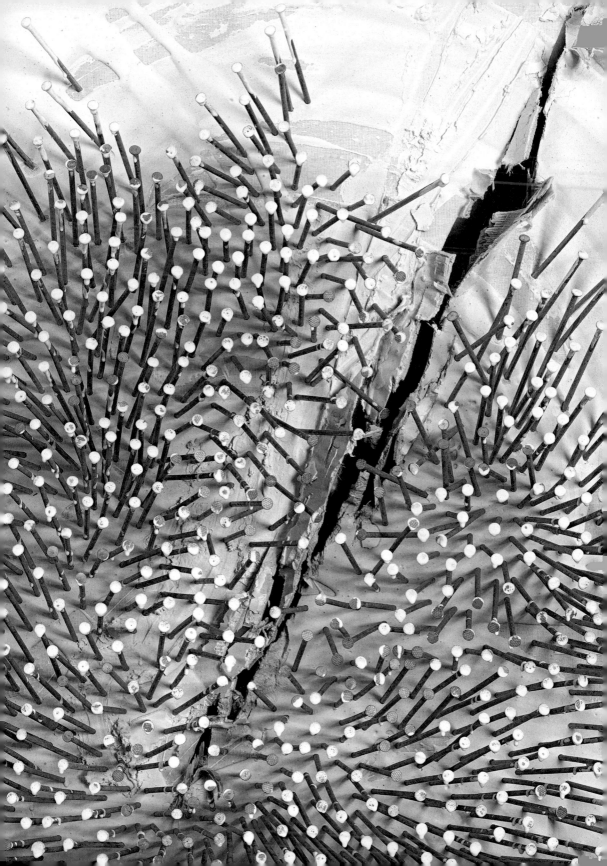

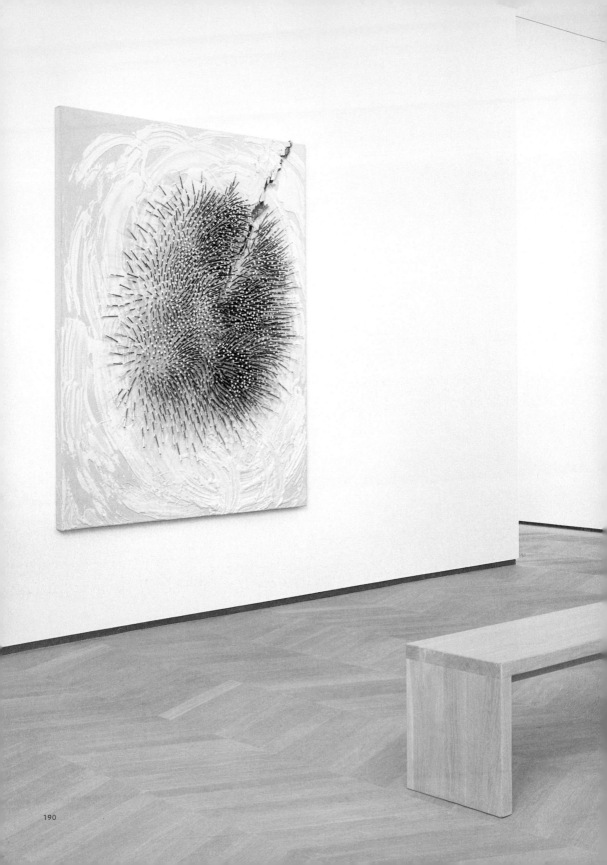

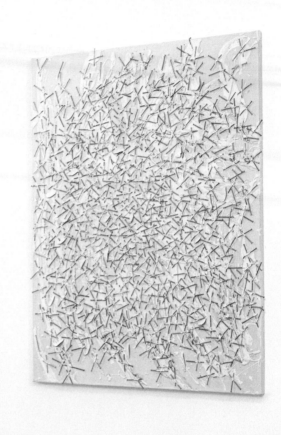

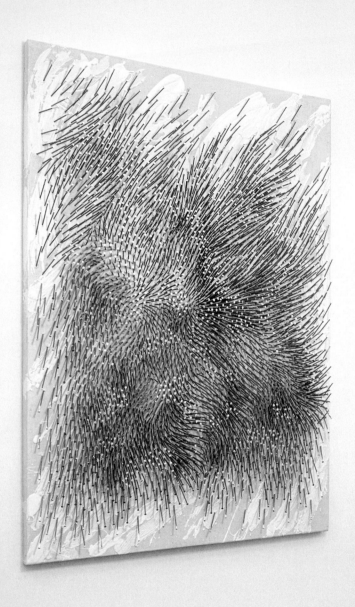

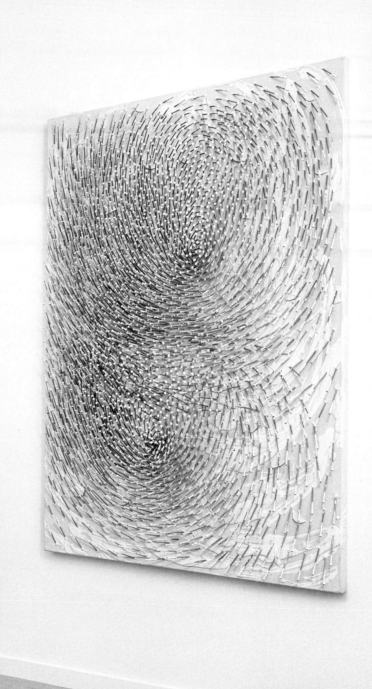

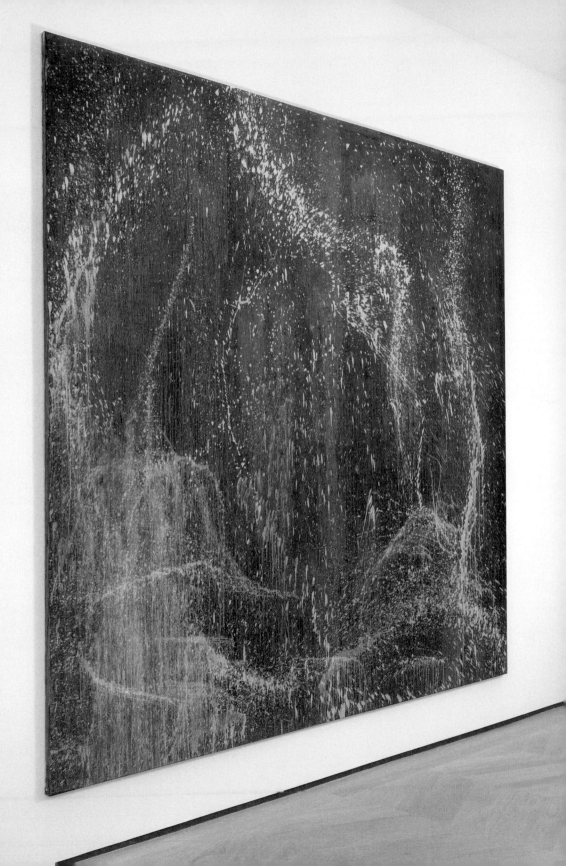

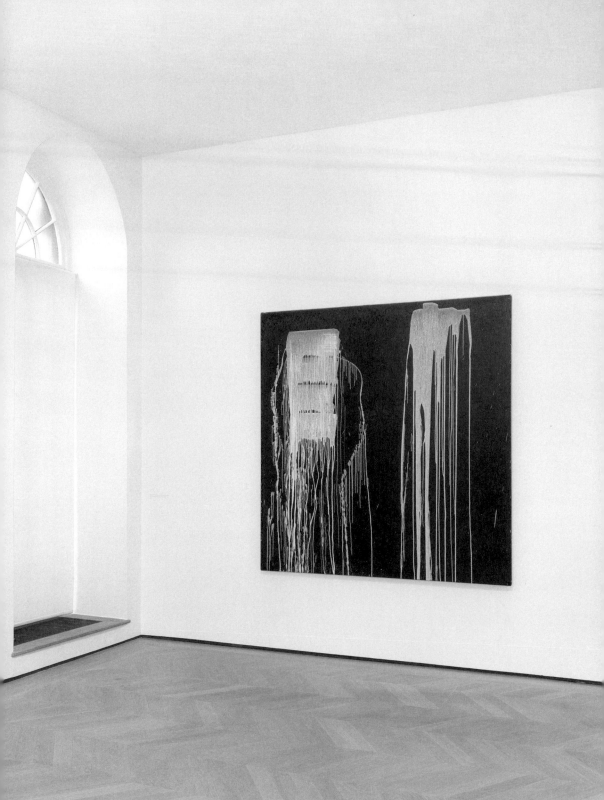

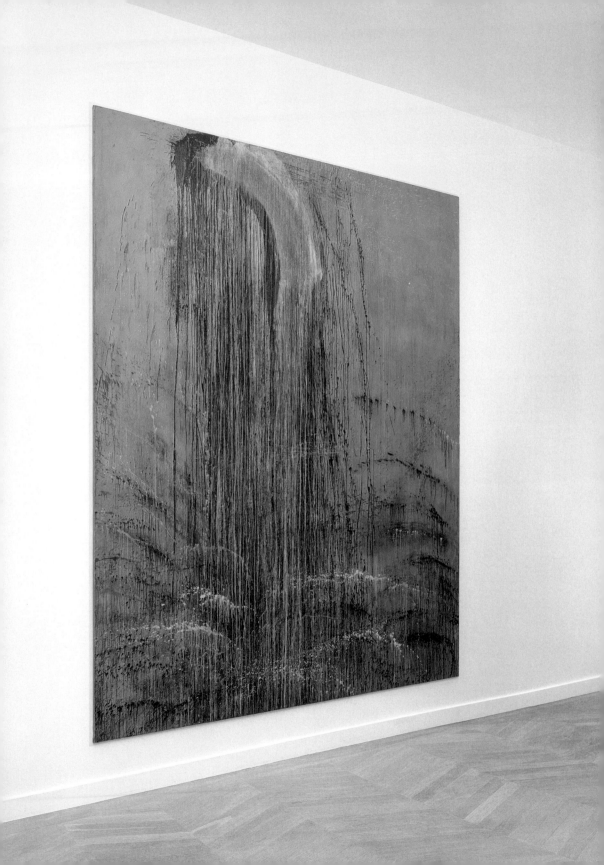

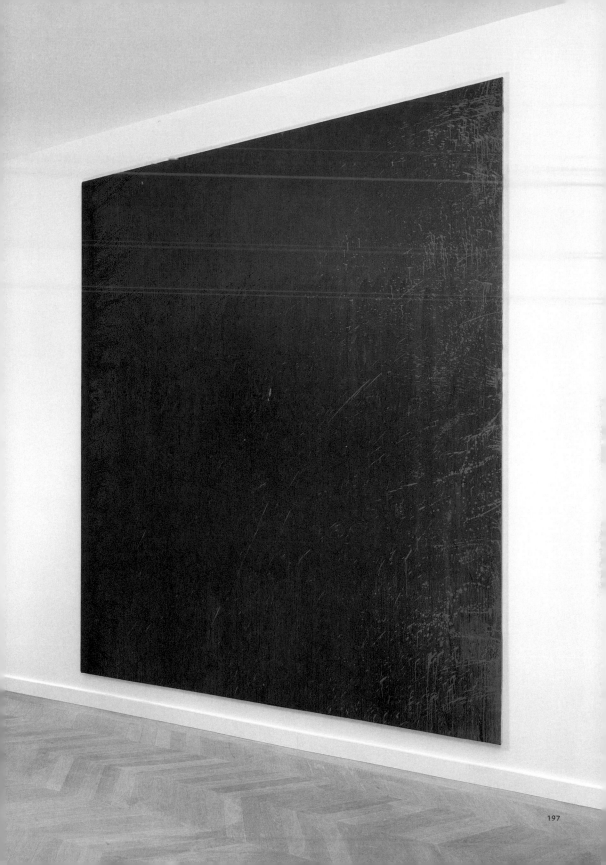

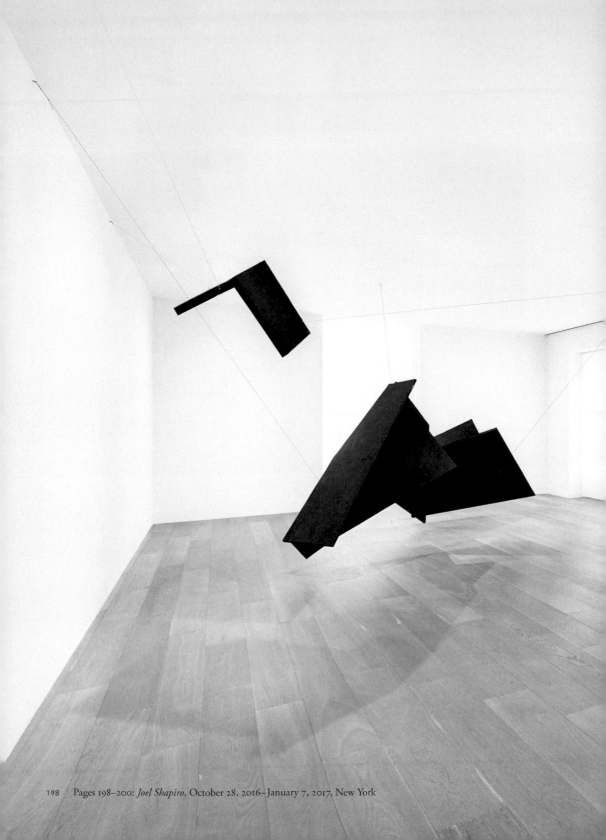

Pages 198–200: *Joel Shapiro*, October 28, 2016– January 7, 2017, New York

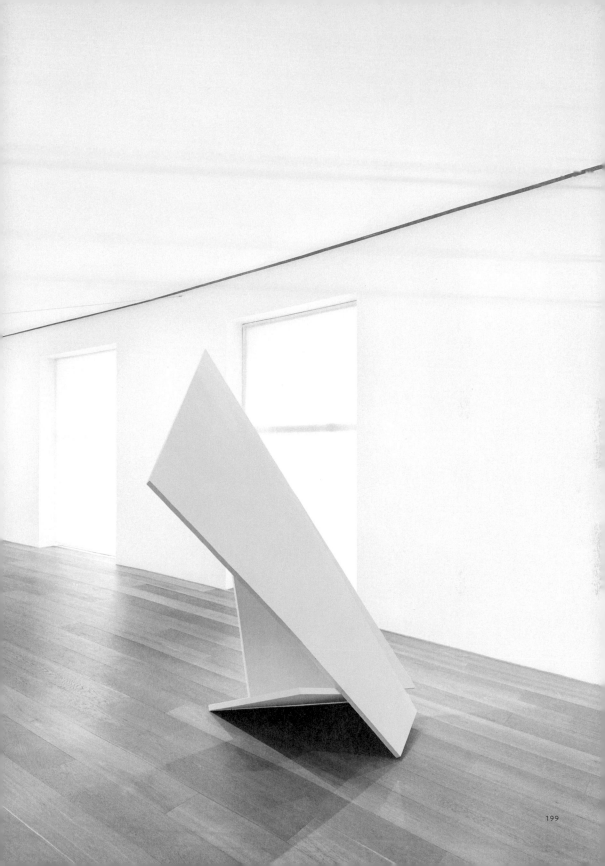

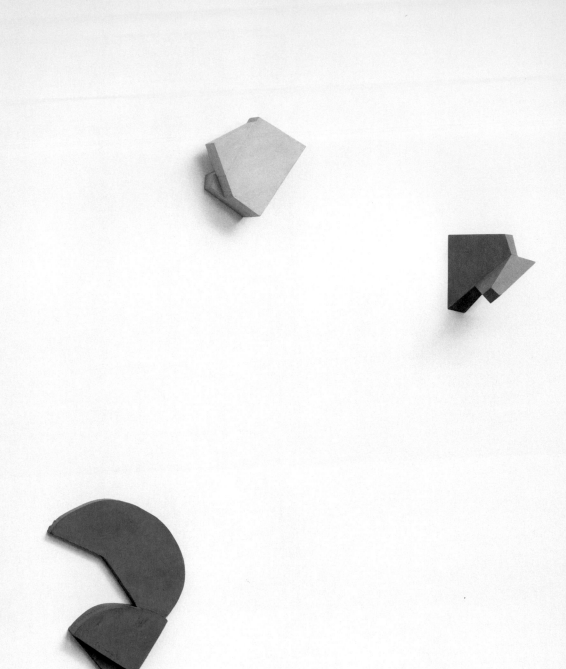

On Balance

ANGE MLINKO

"To be anchored. Not to be anchored…
We respond to a form that seems to stretch or lean."
—Joel Shapiro, interview, 2007

I don't remember gathering
in drips and drabs
by the *Broken Obelisk*,
the chards and cabs

in plastic cups, to celebrate,
oh, something or other—
while the air in Houston was mild,
and right there a new mother

tilted toward the reflecting pool
her offspring; which, if it did spring,
would unreflectingly imitate
the boy who weds himself in a ring

of ecstatic ripples. I think
an emphasis on buoyancy
appropriate to a city of bayous,
the Rothko Chapel and Beyoncé.

*

I don't remember live oak colonnades,
and the fish-bowl glass at which I idled,
awed, regarding the beam
aimed at me from *Untitled*.
The sculpture could seem
to be the disassembled blades

of Icarus' wings, or the nine Muses
hanging midair, tickled at
the fall of Pyreneus,
who lands splat
trying to trap them in his palace…
as if love or art could be got like that.

<p style="text-align:center">*</p>

I don't remember being a girl
at the Rodin Museum
downwind of the Calder,
puzzling out Rilke, sure that the world
was more than the sum
of its parts: Because Calder.

Because *Bird in Space.* Because
The Bride Stripped Bare
by Her Bachelors, Even.
Once, there was the loss
of my return fare.
I felt these deities intervene,

because the conductor let it go.
For the long backward ride
through the station stops of the Main Line,
I sensed the stones, which Deucalion and Pyrrha throw
behind them, vivified;
the boundary between stone and man that fine.

<p style="text-align:center">*</p>

I don't remember looking at an anchor
and trying to understand its shape;

the one my dad would lob like a discus
instead of dropping plumb. It wasn't rancor,

and it wasn't aimed at the landscape.
It was never something I sought to discuss.

But over the toe-groped clay of the Delaware,
or in the silt of the wider Chesapeake,

or even in the Gulf (the gonging dolphins
amid the legs of the oil rigs, the reek

of petroleum intruding on endorphins
triggered by the sea wind), the skies

were heavy with questions of form.
They amassed like desserts. The ships

passed, and frigate birds. What surprise
might emerge from a synapse storm?…

(e.g., sea nymph Thetis and her shifting shapes).

*

The moment the mother righted the child,
laughter bubbled. There was a general suspension
of belief in disaster, all tales that evening spun
from the conviction that the Fates have smiled,

and that one doesn't still carry scissors under
her business suit to snip the thread—not unlike
a top-of-cumulus-to-earthroot lightning strike
that kills before you even hear the thunder.

(Aren't scissors for sneaking, in protective sock,
as you steal across the field of vision,
your straw boater tipped, to make a first incision
in a library book or branch of neighbor's lilac?)

That's when I remember that just then
the moon snuck up on us. Guardian of
discarded myths, romantic love,
negative capability, supreme fiction:

it bobbed into the viewing environment,
I realized, no less than the baby's head
on which we heaped our hopes and pled
innocent, innocent, innocent.

Note to the Poem: "On Balance" uses the armature of Ovid's *Metamorphosis* to give formal unity to five loosely grouped meditations on shape and shape-shifting. Each of the sections takes a different rhyming stanza form, inspired by the wall reliefs and suspended shapes in Joel Shapiro's recent exhibition at the Nasher Sculpture Center. The poem is something of a comedy, also inspired by Shapiro's credo of playfulness and liveliness: "I want it to be lively," he says in a video about his Houston installation from 2012. (Section 2 of this poem details my recollection of seeing this show.) Since Shapiro uses *Untitled* for so many of his works, eschewing convenient linguistic guideposts, I had almost nothing to fall back on except an unmediated looking—and feeling. Chiefly, the feeling was one of precarious balance. I hope this poem evokes precarious balance with similar felicity.

—Ange Mlinko

—*Commissioned for the exhibition catalogue* Joel Shapiro, *2016*

These Pieces

adjust the air
or its
pressure the space around them where
lines meet

sometimes and
sometimes not who knows how or
why, really
it's happening here, just so
through this poem
of a room we roam
inside ourselves, these stanzas

◊

Is it beauty
buoyed up
or ungainli-
ness itself as such
that holds us here

& what's
holding this one
there
above us?

Hmmm—

not clear at all but clearly
something
beyond
itself

◊

About that deployment
of shapes

 and the spaces

 between them—

 it all works out,
 so long
as you don't take it
 too seriously, he says,

 seriously.

◊

Neither right
nor wrong, not even
right
 exactly
 or left,

just the sprawling
 soaring fall
and call of

all of it

◊

and the color: how
 delicate
is that

 slung
 piece of plywood
painted a once-
crushed
 Paris blue
 cutting
into the lime view
 at an angle
 to the off-
 white wall proposing—
 This
 is how
 it is in relation
to that
 and the beyond
 any bubble
 gum pink

skin
 to begin with

◊

Floating motes of
punctuation
 or tilted
 syllables in the
 sentence of our walking
around and through them thinking

of things,
for instance, with Hopkins—

> "Say, beauty lies
> but in the meet
> of lines,
> or careful
> spaced sequence of sounds."

◊

Are these songs
of degrees
 increments
 (in their way)
of an inter-
 rupted descent

or broken descant

 strung from fishing
line or guy
 wired (like words) hovering
 in a breeze within that
 plays these beams
 and cords like chords

◊

It's not a linear
narrative like a novel, but
 you can definitely see it
more the way you could read
a part
 of a poem—one
 part of a poem can be
significant
 in itself.
Poets might disagree.

◊

Sly,
a little
 wily, and why
 not

who's to say it
isn't sublime

or only
about a pitch and dis-
 tribution of certain
 values just that

something more we're always
 falling into or for
and possibly from having
failed
 to reach
it or for it

 (slipping)

thought's projection
 into space
weighted with waiting
 almost defying

gravity's say in the whole

matter
of floors and choreo-
 graphed boards
 a set of planks or long
 box blocks and a lozenged
 slice of spruce…
its unfolding
 recomposing
 at once itself

and, yes, you
too, viewer, reader, hanger-
 on to what's
 been hung are
installed within this
 instillation site-
specifically
 and oh so perfectly
 pitched in
its ambivalence

◊

Go figure, the figures seem to
 say—in their almost
 swaying

 how it is
 that what we mean
 is what we stand
 between,
 always
 an after and then
 what
was before that always
 at least

 two things come
 together (or more)
 to form—

all that abstraction, it's
so human.

—*Commissioned for the exhibition catalogue* Joel Shapiro, *2016*

from Cry Stall Gaze

ANNE WALDMAN

imagine a fan or scroll opening out in ancillary space…

[suggest]

 what did you say of it, of her
suggest: snap of fluted fan
then it opens again, sweet anodyne
did you say a canvas of seeing and being, of seething
& bleeding?
 a comet blazes across a scarred landscape
saving you
 from destructive emotions
suggest: charisma, her arc intrudes
 pull down, or resist that pull
as city dweller, as one under slash & burn, suggest
 strobe or stands of light, filaments that some thought
 would move Mohenjo Daro into dreamier reaches of time.

 suggest: a stretch
 might evanesce into dystopia
in a place sealed up like a time capsule
notice there's archeological evidence for beauty
& water running & delineation of desire…hers….or mine
forceful thrust onto white space

lover suggests clearing forests
move together over a land bridge now, scent of hunt…bristle of fox

 magic totem the suggestion of your art

let's go there migrate inside a mammalian cavity one more time

suggest the film be held accountable by savage flickers
 held heart in flickers in hand,
"I know that's so so female of me"

[pour]

hello my stranger, Antarctic Current
vague stories of this hue a substance beholden to eels and
what lives below
hello my stranger
come into my mottled world

of ships, carriage trade....parchment or china buttons...

independent kingdoms resolve toward textured pigment

a line or lugubrious building a shape of occupational hazard
get out before it tumbles

 to ground

we pour concrete
 work together muscle
what happened to the Anasazi?

 we must have
timber pour of pottery stone what happened?
what happen to trade
exchange and barter of goods loveliness & loneliness in
 poured objects

where did they go to what point or line
of demarcation /extinction
the map shimmers

soil nutrient exhaustion.
the duty of collapse. dig under. many centuries happen

& work your heart out
back to this

and would you flee?
or resist? what opens?
sisters flow the line together

[suggest 2]

as ordered

as conjectured

as in the diversity of tangible things

 not immediately seen by the eye
as in her pouting mouth rising to be kissed

as in "a dense cloud: filled with color & incident"
 as in "keeping options open"

she said to me: sweep the ashes
 i took this as slant scant pleasure

this was profuse, this was in the country of take your seat

 forget "could she?"

& what exactly do ashes mean?

as filaments are

as flames of language resist domination

mercurial light
that would cast a reflexive stance a shadow on all you might do

it was the time before the new attack (o get us out of here!)

& she hit the canvas
& she hits the street

 running

[votary]o

figure of touch i coded

hunt or haunt
she wanted or taunted

 some queen vibe with votaries on knees

 enter a square of vipers

brackets because seen within seen within the "seen" is still hidden

[scroll]

end of a tunnel
 draw a map that left space for "vast" "unknown"
[scroll down this dream]
 sing or speak st st tttttt er

she makes it nomad space

rife with animal lore & held captive

 even skin of a wapiti enters and holds its own hold its manna from long ago

striated by years of run hide hold

 look into the concentric patterns

& go horizontal to burst above tree-line

 the way is paved in this tactile field

& only visible to itself, shimmering
shattered filaments, thought-dodges

[your hand]

— phenomenological evidence of hand

— but it is your hand opens an ornamental fan

[on one side the pleasures of peace /other, excoriating scenes of torture]

 strange kind of spiral "staircase" thing
 past present future past de-constructive tendencies is a kind of love is a kind
of eros
 formulated in positional heterodoxy
 or hate?

— is your hand a prison?

— prism for a lover, hand holding the ornamental fan

— i will not believe you didn't come here especially to learn something

— did not capitalize the substance of your seeing but became swept up in it

—— it buttresses us up, this construct, it makes us bow forward it makes us dizzy
 in its unspeakable tableau

[pause]
- could it be merely an object's shadow

[curtain]

strokes identity
bardo identity
kinship identity
species identity
strike-first-policy identity

interjection identity
folly identity
time passing
how?

what do I miss of my tribe those now elders
survived the sixties?

what we did witness with our oracles & manacles

who escaped
who fled
what weird city?

 journey through mountains, crystalline streams, mist rising

 wanted, for example, our eyes behind your curtain of the
waterfall

she pours the desert
she pours the mountain
she pours the stars
she pours the mist
she pours the waterfall
she pours the transient moment
she lingers and then she pours
she pours "image"
she pours "text"
she pours "sentence"

[sentence]

fingers & fingertips

 feverish dominance of palm prints of youth in
caves

leave their mark
 was here was here too i was here and i was too i saw and i saw
too
tiger teeth & curve of back & belly
 smile of the herd i worshipped here too
stuck my hand in ochre on the wall of the cave

 we were herded

what is intentionality in the Neanderthal?

 dream many centuries hence

 & what detritus in indeterminacy, my chance
operation of your words?

 eros of the animal you might be stalking

 febrile young thing

 tactility
of the hide

 fur hides beating heart

 passion cuts through time

 wonder the rituals that made a lantern of a thought

 shadow
or light

 revving up because that was the sentence before you said

 "metabolic"

before you thought before you said radical pluralization of memory

[lines and scars]

highest passes reach nearly 8 thousand feet the road
(whole area dominated by Berber tribes)

 a trail scratched across
rocks

do not eat this caravan

Poet Biographies

EDMUND BERRIGAN

is the author of the poetry collections *We'll All Go Together* (Fewer & Further Press, 2016) and *Glad Stone Children* (Farfalla Press, 2008), and the memoir *Can It!* (Letter Machine Editions, 2013), among other books. He is an editor for the poetry magazines *Vlak*, *Brawling Pigeon*, and *Lungfull!*. Berrigan writes, records, and performs music as I Feel Tractor.

MEI-MEI BERSSENBRUGGE

is the author of 12 books of poetry, including *Hello, The Roses* (New Directions, 2013) and *I Love Artists* (University of California Press, 2006). She has received two American Book Awards, two Asian American Literary Awards, and the PEN West Award. Berssenbrugge has been a contributing editor of *Conjunctions Magazine* since 1978.

PETER COLE

is a poet and translator. He is the author of 4 poetry collections, including *The Invention of Influence* (New Directions, 2014), and the editor of the anthology *The Poetry of Kabbalah: Mystical Verse from the Jewish Tradition* (Yale University Press, 2012). His many accolades include a Fellowship from the MacArthur Foundation.

LEOPOLDINE CORE

is a poet and fiction writer. Her works include the collection of stories *When Watched* (Penguin Press, 2016) and the poetry volume *Veronica Bench* (Coconut Books, 2015). She is the recipient of a Whiting Award for fiction and has been awarded Fellowships by the Center for Fiction and the Fine Arts Work Center.

BRENDA COULTAS

is the author of *The Tatters* (Wesleyan University Press, 2014) and *The Marvelous Bones of Time* (Coffee House Press, 2008), among others. She is a New York Foundation for the Arts Fellow and has received residencies from the Lower Manhattan Cultural Council, the Emily Harvey Foundation, and the Millay Colony for the Arts.

TRUCK DARLING

is the author of multiple poetry collections, including *The Hunger Notebooks* (Tender Buttons Press, 2015), *Hold Tight: The Truck Darling Poems* (Hanging Loose Press, 2010), *Blue Collar Holiday* (Hanging Loose Press, 2005), and *A Valentine to Frank O'Hara* (Smokeproof Press, 1999).

ERICA HUNT

is a poet and essayist. Her many publications include *Time Slips Right Before Your Eyes* (Belladonna, 2015) and *Local History* (Roof Books, 2003). She was the recipient of the 2001 Grants to Artists award from the Foundation for Contemporary Arts and the 2005–06 Fellowship in Poetics and Poetic Practice at the Center for Programs in Contemporary Writing, University of Pennsylvania.

JOEY DE JESUS

is a poet whose work has appeared in *Barrow Street, Beloit Poetry Journal, Brooklyn Magazine, The Cortland Review, Devil's Lake, Drunken Boat, Guernica, Harriet, RHINO, Southern Humanities Review,* and elsewhere. He was the winner of the *LUMINA* vol. XI poetry contest. He is a poetry editor at *Apogee Journal* and teaches at ASA College.

VINCENT KATZ

is the author of 13 books of poetry, including *Southness* (Lunar Chandelier Press, 2016) and *Swimming Home* (Nightboat Books, 2015). He was the recipient of the 2005 National Translation Award and the 2001–02 Rome Prize Fellowship in Literature from the American Academy in Rome. Katz is an instructor at the Yale University School of Art and curator of the Readings in Contemporary Poetry series at Dia Art Foundation.

AMY KING

is the recipient of the 2015 WNBA Award from the Women's National Book Association and was selected by the Feminist Press as one of the "40 Under 40: The Future of Feminism." Her poetry collection, *The Missing Museum* (Tarpaulin Sky Press, 2015), won the Tarpaulin Sky Book Prize. She serves on the executive board of VIDA: Women in Literary Arts.

ANGE MLINKO

is the author of four collections of poetry, including *Marvelous Things Overheard* (Farrar, Straus and Giroux, 2013). She is poetry editor of *The Nation* and has been the recipient of the Poetry Foundation's Randall Jarrell Award in Criticism, as well as a Guggenheim Fellowship. Mlinko is associate professor of English at the University of Florida, Gainesville.

YUKO OTOMO

is a poet, artist, critic, essayist, and translator. Her recent book *STUDY & Other Poems on Art* (Ugly Duckling Presse, 2013) assembles her ekphrastic work in poetry. Her visual work has been exhibited at Tribes Gallery, Anthology Film Archives Courthouse Gallery, the Vision Festival, and the Brecht Forum.

CECILIA PAVÓN

is a poet and fiction writer. She was co-founder in 1999 of Belleza y Felicidad, the experimental gallery space, cultural center, and press in Buenos Aires. Recent works include the first volume of her collected poems, *A Hotel With My Name* (Scrambler Books, 2015), translated by Jacob Steinberg, and the selected writings *Belleza y Felicidad* (Sand Paper Press, 2015), translated by Stuart Krimko.

MARY REILLY

is a poet, writer, and translator currently studying at Columbia University. Her work has appeared in the anthology *Bowery Women*, edited by Bob Holman and Marjorie Tesser (YBK Publishers, 2006), and in *The New York Quarterly*. Reilly is the recipient of the 2016 Beeson Fellowship and a 2016 Trelex Residency. She participated in *the waves cycle: an Outranspian experiment in collective translation.*

SARA JANE STONER

is a poet and theorist who has taught at Brooklyn College, Baruch College, and the Cooper Union. Her book *Experience in the Medium of Destruction* (Portable Press at Yo-Yo Labs, 2015) was nominated for the 28th Annual Lambda Literary Award for poetry. She is a PhD candidate at CUNY Graduate Center and serves as reviews editor for *The Poetry Project Newsletter*.

ANNE TARDOS

is a poet and artist. She is the author of nine books of poetry, including *NINE* (BlazeVox Books, 2015). Her multimedia and multilingual works have been presented at the Museum of Modern Art, New York, the West German Radio (WDR), and the XLIV Venice Biennale. She is a Fellow in poetry at the New York Foundation for the Arts.

ANNE WALDMAN

is the author of over 40 books of poetry, including *Voice's Daughter of a Heart Yet to Be Born* (Coffee House Press, 2016), *Manatee/Humanity* (Penguin Poets, 2009), and the feminist epic *The Iovis Trilogy: Colors in the Mechanism of Concealment* (Coffee House, 2011). She was the winner of the 2012 PEN Center USA Award for Poetry. Waldman is the recipient of the Shelley Memorial Award and a Guggenheim Fellowship, and is a chancellor of the Academy of American Poets.

KAREN WEISER

is the author of the poetry collections *To Light Out* (2010) and *Or, The Ambiguities* (2015), both from Ugly Duckling Presse. She has been awarded a Robert Rauschenberg Foundation residency, a Process Space residency through the Lower Manhattan Cultural Council, and a New York Foundation of the Arts Fellowship in Poetry.

Exhibitions and Events at Dominique Lévy

Audible Presence: Lucio Fontana,
Yves Klein, Cy Twombly
September 18 – November 16, 2013
New York

PROGRAM
Performance of Yves Klein's
Monotone-Silence Symphony
Conducted by Roland Dahinden
September 18, 2013
Madison Avenue Presbyterian Church
New York

Boris Mikhailov: Four Decades
November 23, 2013 – February 8, 2014
New York

Tsuyoshi Maekawa
February 27 – April 12, 2014
New York

Germaine Richier
February 27 – April 12, 2014
New York

Pierre Soulages
April 24 – June 27, 2014
New York

Gino de Dominicis
July 8 – August 8, 2014
New York

"Hypothesis for an Exhibition"
July 8 – August 15, 2014
New York

Roman Opalka: Painting ∞
September 4 – October 18, 2014
New York

Local History: Castellani, Judd, Stella
October 13, 2014 – January 17, 2015
London

Local History: Castellani, Judd, Stella
October 30, 2014 – January 17, 2015
New York

Body and Matter: The Art of
Kazuo Shiraga and Satoru Hoshino
January 29 – April 4, 2015
New York

PROGRAM
Panel Discussion on Kazuo Shiraga
with Koichi Kawasaki, Alexandra Munroe,
Ming Tiampo, and Reiko Tomii
February 12, 2015
New York

Sotto Voce
February 9 – April 18, 2015
London

Alexander Calder: Multum in Parvo
April 22 – June 13, 2015
New York

Alexander Calder: Primary Motions
April 29 – September 1, 2015
London

PROGRAM
Dance Performance by HeadSpaceDance
June 29, 2015
London

Peter Regli: One Sun—One Moon
June 25 – August 14, 2015
New York

Gego: Autobiography of a Line
September 10 – October 24, 2015
New York

Senga Nengudi
September 10 – October 24, 2015
New York

PROGRAM
Poetry Reading: Anne Tardos
October 22, 2015
New York

Gerhard Richter: Colour Charts
October 13, 2015 – January 16, 2016
London

PROGRAM
Panel Discussion on Gerhard Richter's
Colour Charts with Hans-Ulrich Obrist,
David Batchelor, and Lock Kresler
January 13, 2016
London

Robert Motherwell: Elegy to the Spanish Republic
November 4, 2015 – January 9, 2016
New York

PROGRAM
Dance Performance: *Motherwell Amour*
Performed by the Erick Hawkins Dance
Company and the Manhattan Brass Quintet
Music composed by Lucia Dlugoszewski
December 10, 2015
New York

Drawing Then: Innovation and Influence
in American Drawings of the Sixties
January 27 – March 26, 2016
New York

PROGRAMS
Performance by Jason Moran
January 30, 2016
New York

Poetry Reading: Mei-mei Berssenbrugge
and Leopoldine Core
March 9, 2016
New York

Panel Discussion on Drawings, Now and
Then with Bernice Rose and Kate Ganz
March 15, 2016
New York

Enrico Castellani
February 9 – March 26, 2016
London

Roman Opalka: Passages
April 6 – May 14, 2016
London

Enrico Castellani: Interior Space
April 7 – May 21, 2016
New York

PROGRAM
Poetry Reading: Karen Weiser
and Mary Reilly
New York
May 5, 2016

Hans-Christian Lotz
April 7 – May 21, 2016
New York

Gego: Autobiography of a Line
May 25 – August 19, 2016
London

Chung Sang-Hwa
June 1 – July 30, 2016
New York

PROGRAMS
Panel Discussion on Tansaekhwa
with Chung Sang-Hwa,
Tim Griffin, and Robert C. Morgan
May 31, 2016
New York

Performance: *Solo Rites: Seven Breaths*
Performance by Jen Shyu
June 7, 2016
New York

Poetry Reading: Yuko Otomo
and Edmund Berrigan
June 29, 2016
New York

Antek Walczak
June 1 – July 30, 2016
New York

Karin Schneider: Situational Diagram
September 7–October 20, 2016
New York

PROGRAMS
Poetry Reading: Amy King and Brenda
Coultas
September 17, 2016
New York

Walkthrough of Karin Schneider's
Situational Diagram with Aliza Shvarts
September 23, 2016
New York

Critical Lab on Surveillance
with Bernard Harcourt
September 24, 2016
New York

Dance Performance: *life seems
like a beAten path ?!?*
Performance by Gillian Walsh
September 30, 2016
New York

Poetry Reading: Erica Hunt
and Sara Jane Stoner
October 1, 2016
New York

Poetry Reading: Truck Darling
and Joey De Jesus
October 15, 2016
New York

Günther Uecker: Verletzte Felder
September 23–October 29, 2016
London

Joel Shapiro
October 28, 2016–January 7, 2017
New York

PROGRAM
Poetry Reading: Ange Mlinko and Peter Cole
November 10, 2016
New York

Pat Steir
November 9, 2016–January 29, 2017
London

Unless otherwise stated, all texts and photographs were made available by the institutions or private entities named as their owners. We have made every effort to locate all copyright holders. Any errors or omissions will be corrected in subsequent editions.

TEXT CREDITS

"poetry is on the walls: a preface" © Vincent Katz
"Star, Being" © Mei-mei Berssenbrugge. Previously published in *Drawing Then: Innovation and Influence in American Drawings of the Sixties* (New York: Dominique Lévy, 2016)
"Homage" © Jacques Roubaud, English translation by Charles Penwarden. Previously published in *Roman Opalka: Painting ∞* (New York: Dominique Lévy, 2014)
"Homage to Calder" by Karl Shapiro. Previously published in *The New Yorker* © 1952, 1980 Karl Shapiro. Published by permission of Harold Ober Associates Incorporated. Included in *Alexander Calder: Multum in Parvo* (New York: Dominique Lévy, 2015)
"Kind Ghosts" © Cecilia Pavón, English translation by Jacob Steinberg
"Materia," "Materia IX," and "autosacrifice" © Joey De Jesus
"Artist Statement #2," "Artist Statement #3," and "Stretching Canvas" © Truck Darling
"GEGO" © Anne Tardos. Previously published in *Gego: Autobiography of a Line* (New York: Dominique Lévy, 2015)
"All Elegies Are Black and White" by Barbara Guest. © The Estate of Barbara Guest. Previously published in *The Collected Poems of Barbara Guest*, Hadley Haden Guest, ed. (Middletown: Wesleyan University Press, 2008), 46–49. Included in *Robert Motherwell: Elegy to the Spanish Republic* (New York: Dominique Lévy, 2015)
"A Bird for Every Bird" by Harold Rosenberg © Estate of Harold Rosenberg. George Wittenborn, Inc. Papers, I.B.25. The Museum of Modern Art Archives, New York. Included in *Robert Motherwell: Elegy to the Spanish Republic* (New York: Dominique Lévy, 2015)
"Lament for Ignacio Sánchez Mejías" by Federico García Lorca, from *Federico García Lorca: Selected Verse, Revised Bilingual Edition* (Farrar, Straus and Giroux, 2004 edition), © Herederos de Federico García Lorca. English-language translation by Galway Kinnell, © Galway Kinnell and Herederos de Federico García Lorca. All rights reserved. For information regarding rights and permissions for any of Lorca's works in Spanish or any other language, please contact lorca@artslaw.co.uk. Included in *Robert Motherwell: Elegy to the Spanish Republic* (New York: Dominique Lévy, 2015)
"To The Songbird Fallen on the Forest Floor" © Brenda Coultas. Previously published in *Portia Munson: Little Suns Hollow Bones* (Saugerties, NY: Cross Contemporary Art, 2015)
"Love Poems from 2001" and "It's Hard" © Leopoldine Core
"Untitled" and "Garden at Night" © Mary Reilly
"[Twins and immaculate inseminated]" © Bruno Corà, 1985. English translation by Howard Rodger MacLean. Previously published in *Enrico Castellani* (London: Dominique Lévy, 2016)
"Trous (Holes)" by Emilio Villa, 1996. English translation by Sylvia Gorelick. Previously published by Proposte d'Arte Colophon, 1996. Published by permission of Edizioni Colophon. Included in *Enrico Castellani* (London: Dominique Lévy, 2016)
"Spells for Solids" © Karen Weiser
"Bill & Ted's Excellent Adventure" © Edmund Berrigan. Previously published in *The Brooklyn Rail*, July 11, 2016. *Note: This poem is composed of lines taken from Bill Berkson's* Blue is the Hero *(L Publications, 1976) and Ted Greenwald's* Jumping the Line *(Roof Books, 1999).*
"[Died in a back bone]," "Quipment," and "Struggle" © Edmund Berrigan
"[I'm not a guy who]" © Edmund Berrigan. Previously published in the magazine *Positive Magnets*
"Path" © Yuko Otomo. Previously published in *Chung Sang-Hwa* (New York: Dominique Lévy and Greene Naftali, 2016)
"A Performance Architecture: A response to *Situational Diagram* by Karin Schneider" and "Broken English" © Erica Hunt
"Ode to the Artist in his Natural Habitat" © Amy King
"If I am Teachable" © Sara Jane Stoner
"On Balance" © Ange Mlinko. Previously published in *Joel Shapiro* (New York: Dominique Lévy, 2016)
"These Pieces" © Peter Cole. Previously published in *Joel Shapiro* (New York: Dominique Lévy, 2016)
"Cry Stall Gaze" © Anne Waldman. Excerpted from the collaboration *Cry Stall Gaze*, 2012–14, Accordion book with silkscreen and photogravure, 15 × 216 inches (38.1 × 548.6 cm) © Pat Steir and Anne Waldman, Brodsky Center, Rutgers University, New Brunswick

EXHIBITION PHOTOGRAPHS

Cover and pages 17–21, 26–29, 38–41, 44–47, 77–87, 92–95, 121–127, 130–131, 153–157, 198–199: Photographs by Tom Powel Imaging; pages 17–21: Yves Klein © Yves Klein/Artists Rights Society (ARS), New York/ADAGP, Paris 2016; cover, pages 18–21, 42: Lucio Fontana © 2016 Artists Rights Society (ARS), New York/SIAE, Rome; pages 19–20: Cy Twombly © Cy Twombly Foundation, 2016; pages 22–25: Germaine Richier © 2016 Artists Rights Society (ARS), New York/ADAGP, Paris; pages 22–25, 34–37, 48–51: Photographs by Guillaume Ziccarelli; pages 26–29: Boris Mikhailov © 2016 Boris Mikhailov; pages 30–33: Pierre Soulages © 2016 Artists Rights Society (ARS), New York/ADAGP, Paris. Photographs by Vincent Cunillère; pages 34–36, 158–159: Courtesy Dominique Lévy; pages 38–41, 128–132: Enrico Castellani © 2016 Artists Rights Society (ARS), New York/SIAE, Rome; pages 38–41, 122: Frank Stella © 2016 Frank Stella/Artists Rights Society (ARS), New York; page 39: Donald Judd © 2016 Judd Foundation/Artists Rights Society (ARS), New York; page 42: Piero Manzoni © 2016 Artists Rights Society (ARS), New York/SIAE, Rome; pages 42–43: Photographs by Leon Chew; pages 42, 189–193: Günther Uecker © 2016 Artists Rights Society (ARS), New York/VG Bild-Kunst, Bonn; page 43: Luis Tomasello © 2016 Artists Rights Society (ARS), New York/ADAGP, Paris, and Louise Nevelson © 2016 Estate of Louise Nevelson/Artists Rights Society (ARS), New York, and Mira Schendel © Mira Schendel Estate; pages 44–46: Satoru Hoshino © Satoru Hoshino; pages 44–47: Kazuo Shiraga © Kazuo Shiraga; pages 48–52: Roman Opalka © 2016 Artists Rights Society (ARS), New York/ADAGP, Paris; page 52: Photograph by André Morin; pages 77–81, 160–161: Gego © Fundación Gego; pages 82–85: Alexander Calder © 2016 Calder Foundation, New York/Artists Rights Society (ARS), New York; page 86: Photograph by Adam Avila; pages 86–87: Senga Nengudi © Senga Nengudi; page 87: Photograph by Harmon Outlaw; pages 88–91, 128–129, 132, 189–197: Photographs by Alex Delfanne; pages 88–91: Gerhard Richter © Gerhard Richter, 2016; pages 92–96: Robert Motherwell © Dedalus Foundation, Inc./Licensed by VAGA, New York, NY; page 96: Courtesy Philadelphia Museum of Art: 125th Anniversary Acquisition. Gift (by exchange) of Miss Anna Warren Ingersoll and partial gift of the Dedalus Foundation, Inc., 1998-156-1 © Dedalus Foundation/Licensed by VAGA, New York, NY; pages 121–122: Agnes Martin © 2016 Agnes Martin/Artists Rights Society (ARS), New York; page 122: Josef Albers © 2016 The Josef and Anni Albers Foundation/Artists Rights Society (ARS), New York; page 123: Brice Marden © 2016 Brice Marden/Artists Rights Society (ARS), New York, and Eva Hesse © The Estate of Eva Hesse. Courtesy Hauser & Wirth, Zürich; page 124: Tom Wesselmann © Estate of Tom Wesselmann/Licensed by VAGA, New York, NY and Ed Ruscha © Ed Ruscha. Courtesy Gagosian Gallery, and Jo Baer © Jo Baer, and Andy Warhol © 2016 The Andy Warhol Foundation for the Visual Arts, Inc./Artists Rights Society (ARS), New York, and Robert Ryman © 2016 Robert Ryman/Artists Rights Society (ARS), New York; page 125: Michelle Stuart © Michelle Stuart. Courtesy Leslie Tonkonow Artworks + Projects and Marc Selwyn Fine Art, and Adrian Piper, *Drawing About Paper, Writing About Words #17*, 1967. Pastel, ink, paper cutouts, glue on paper. 11 × 8.5 inches (27.9 × 21.6 cm). Private Collection, USA. © APRA Foundation Berlin, and Agnes Denes © Agnes Denes. Courtesy Leslie Tonkonow Artworks + Projects. Collection of Whitney Museum of American Art, and David Smith © The Estate of David Smith/Licensed by VAGA, New York, NY; page 126: Mel Bochner © Mel Bochner; page 127: Claes Oldenburg © Claes Oldenburg. Courtesy Pace Gallery, and Robert Rauschenberg © Robert Rauschenberg Foundation/Licensed by VAGA, New York, NY; pages 153–157: Chung Sang-Hwa © Chung Sang-Hwa; pages 158–159: Photographs by Elisabeth Bernstein; pages 160–161: Photographs by Matthew Hollow; pages 162–164: Karin Schneider © Karin Schneider; pages 162–164, 200: Photographs by John Berens; pages 194–197: Pat Steir © Pat Steir; pages 196–200: Joel Shapiro © 2016 Joel Shapiro/Artists Rights Society (ARS), New York

In most cases, full captions for the individual works pictured in these photographs can be found in the catalogues accompanying the listed exhibitions.

Symmetries

THREE YEARS OF ART AND POETRY AT DOMINIQUE LÉVY

DOMINIQUE LÉVY

909 Madison Avenue
New York, NY 10021
T: +1 212 772 2004
dominique-levy.com

Founder: Dominique Lévy
Senior Director: Emilio Steinberger
Directors: Leila Saadai, Begum Yasar
Director of Exhibitions: Clara Touboul
Director of Operations: Cari Brentegani
Director of Communications: Mackie Healy
Registrar: Liz Nelson
Exhibitions Coordinator & Poetry Curator:
Sylvia Gorelick
Exhibitions Researcher: Valerie Werder
Gallery Associate: Andrew Kachel

Catalogue © 2016 Dominique Lévy

Design: McCall Associates, New York
Printing and Binding: Trifolio SRL, Verona
Copy Editing: Sarah Wolberg

ISBN: 978-1-944379-13-1

Printed and Bound in Verona and Available
through ARTBOOK | D.A.P.
155 Sixth Avenue, 2nd Floor, New York, NY 10013
Tel: 212 627 1999 Fax: 212 627 9484

Cover: Lucio Fontana, *Concetto Spaziale, Attese*, 1966. Water-based white paint on canvas, 25 1/2 × 21 1/4 inches (65 × 54 cm). Photograph by Tom Powel Imaging. © 2016 Artists Rights Society (ARS), New York / SIAE, Rome

Page 17: Yves Klein, *Pluie Bleue*, 1961. Dry pigment in synthetic resin on twelve separate hanging wood dowels, 82 1/4 × 12 × 7/16 inches (208.9 × 30.5 × 1.1 cm). Photograph by Tom Powel Imaging. © Yves Klein / Artists Rights Society (ARS), New York / ADAGP, Paris 2016

Page 52: Roman Opalka, *OPALKA 1965/1−∞ Détail 993460−1017875* (detail). Acrylic on canvas, 77 1/16 × 53 1/8 inches (196 × 135 cm). Photograph by André Morin. © 2016 Artists Rights Society (ARS), New York / ADAGP, Paris

Page 77: Gego, *Chorro No. 3*, 1970. Aluminum and stainless steel, 53 15/16 × 25 1/4 × 7 7/8 inches (137 × 64 × 20 cm). Photograph by Tom Powel Imaging. © Fundación Gego

Page 96: Robert Motherwell, *Elegy to the Spanish Republic* (detail), 1958–61. Oil and charcoal on canvas, 68 × 99 1/2 inches (172.7 × 252.7 cm). Courtesy Philadelphia Museum of Art: 125th Anniversary Acquisition. Gift (by exchange) of Miss Anna Warren Ingersoll and partial gift of the Dedalus Foundation, Inc., 1998-156-1. © Dedalus Foundation, Inc. / Licensed by VAGA, New York, NY

Page 121: Agnes Martin, *Stars* (detail), 1963. Ink and watercolor on paper, 12 × 12 inches (30.5 × 30.5 cm). Photograph by Tom Powel Imaging. © 2016 Agnes Martin / Artists Rights Society (ARS), New York

Page 132: Enrico Castellani, *Superficie bianca–Dittico* (detail), 2008. Acrylic on canvas (in two parts), 98 1/2 × 59 inches (250 × 150 cm). Photograph by Alex Delfanne. © 2016 Artists Rights Society (ARS), New York / SIAE, Rome

Page 153: Chung Sang-Hwa, *Untitled 013-11-20* (detail), 2013. Acrylic on canvas, 63 7/8 × 51 1/4 inches (162.2 × 130.3 cm). Photograph by Tom Powel Imaging. © Chung Sang-Hwa